THE MARCHES IN PHOTOGRAPHS

BRYAN PHILLIPS

AMBERLEY

First published 2020

Amberley Publishing
The Hill, Stroud
Gloucestershire, GL5 4EP

www.amberley-books.com

Copyright © Bryan Phillips, 2020

The right of Bryan Phillips to be identified as the Author of this work has been
asserted in accordance with the Copyrights, Designs and Patents Act 1988.

ISBN 978 1 4456 8690 5 (print)
ISBN 978 1 4456 8691 2 (ebook)

British Library Cataloguing in Publication Data.
A catalogue record for this book is available from the British Library.

Typesetting by Aura Technology and Software Services, India.
Printed in the UK.

ACKNOWLEDGEMENTS

I am indebted to a number of people for their support in capturing many of the images in this book. My wife, Avril, is my inspiration, my guide and my gear-carrying companion for many of my journeys and treks through the county and beyond. She is the steadfast deliverer of lens and camera changes as I see and try to capture the time-bound images in front of me, always looking for a perfect shot. My eldest daughter, Lorraine (also a photographer), has been a stand-in when those early morning shots demand waking at 3 or 4 a.m. to travel to a site in the dark in order to capture those unique impressions of sunrise. Cheryl is my youngest and she keeps me in touch with the new technology and media developments such that I can successfully stay in touch with those who have followed my journey as Lightlog – with an aim to capture and replicate the light show that I see as I travel and note locations for future potential work.

This is my second publication with Amberley. The first, *Kent in Photographs*, has been very well received. The support I have received from friends, family and colleagues has encouraged me to expand my reach with this second book.

ABOUT THE PHOTOGRAPHER

Bryan Phillips is a proud Black Country man, growing up in the middle of the country among the steel-making industries the area is famed for. He has been the subject of a number of events showcasing his work, expressing his images through a variety of different media and formats.

'It's all about the light' is a frequent phrase used by Bryan, referring to the natural light element that is so important in building his images for reproduction. This knowledge brings the realisation that each location has a series of potential results depending on the immediate light conditions, and so a return to the same location builds a library of images that can look quite different. Being an 'early bird', sunrise is an important time for him, and you will see the results of some of these in the pages that follow.

In his daily life, Bryan is a marketing and sales professional in the technology industry, and this is where his association with the Welsh Marches began. Malvern was seen by the family as the perfect location to use as a base: it was within easy reach of South Wales and had a stunning location on hand in the Malvern Hills. As he will tell you, Bryan always has a camera at the ready as he travels through and around the county (as well as the world) – there are often opportunistic captures that await the ever-ready photographer. Of course, there are those shots that were missed when time pressures or mode of transport meant that a halt was not possible, even if only for a moment.

Bryan has successfully presented images for the BBC, a US backpacker's guide and various projects around the country, but he still enjoys the buzz of a gallery show where visitors often remark on the detail found in the canvases and prints on display.

Photography is my escape, my safe place, my creative release and I hope that you will be able to see some of that as you look through the images and notes in this book. I have been involved in photography from an early age, growing up with a Kodak Brownie bellows camera and developing my own images either in the loft or darkroom-converted bathroom. Modern equipment is much more versatile and allows high-quality images to be more frequently captured.

The images in this book have been captured using a variety of cameras, lenses and attachments, including:

Cameras: Nikon D850 / Nikon D800 / Nikon D810 / Nikon D700 / Nikon D300

Lenses: Nikkor AF-S 24–120 mm / Nikkor AF-S 16–35 mm / Nikkor AF-S 70–300 mm / Nikkor 200–500 mm

Accessories: Giottos MML3290B Monopod / Tiffen Filters

INTRODUCTION

The Marches often needs some initial explanation; in fact, the term itself is not completely clear. It may come from 'mark' or 'border', signifying a border between territories. In this case we are exploring the Welsh Marches. The border is not perfectly described, having moved quite a lot over a history of hundreds of years. A repeating theme centres around what we now know as Shropshire and Herefordshire, but we include a slightly wider definition for the images contained here.

As a border area, as you might expect, the area is littered with fortifications; however, there are more than just castles, with fortified houses and ancient hill forts dotted around the landscape too. Although named 'the Marches', in fact there is no reference to English marches in common use, therefore we are generally talking about the Welsh Marches here.

Following the Roman occupation of most of Britain, Wales consisted of a number of kingdoms. To fill the void of power after AD 410 the Angles and Saxons established their power bases in southern and eastern Britain, and after a time there was a quest to expand their territories further west. The boundary of Offa's Dyke signalled what would become the key frontier territory. Offa's Dyke can, of course, still be seen in the region.

After 1066 and the Norman Conquest, a few trusted nobles were installed to control this border territory. Hugh d'Avranches, Roger de Montgomerie and William FitzOsbern were given earldoms around the areas of Chester, Shrewsbury and Hereford. It was around this time that 'March of Wales' was first noted – it was used in the Domesday Book (1086). The marcher lords set up a number of controls along the border between the estuaries of the Severn in the south and the Dee in the north.

So we now come to 'Marchia Wallie', or the Welsh Marches, and by the twelfth century the term referred to something like two-thirds of what we know as Wales. Quite an extensive building programme was established in the next 200 years, evidence of which can be seen from examples as far north as Flint and Mold. This was very much seen as the Wild West of Britain until the Industrial Revolution.

The region around Ludlow and Hereford are seen as the centre of the Marches, and the council of Wales and the Marches had its centre of administration in Ludlow, first established in 1472 by Edward IV.

NORTHERN REACHES

Castles at Ewloe (shown here), Flint, Denbigh and Ruthin are evidence of the northern battleground of the border country between Wales and England. Being a border town Chester also has defences, and battlegrounds continue south towards Llangollen and Oswestry.

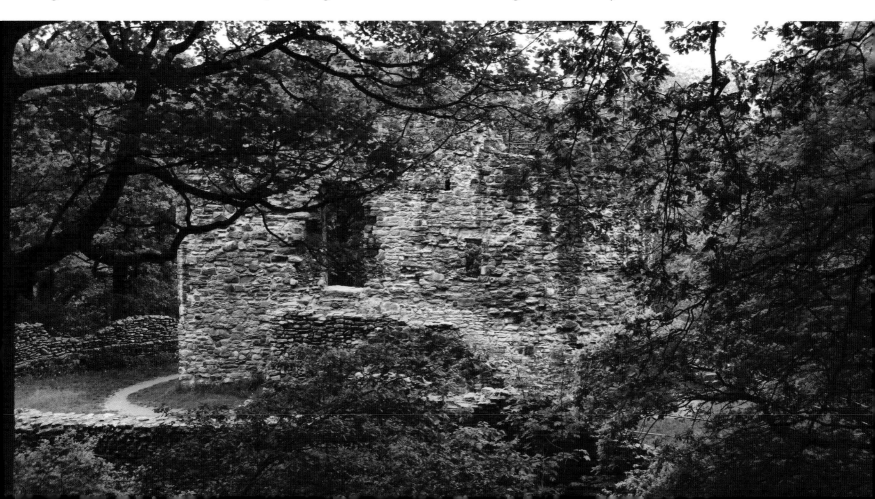

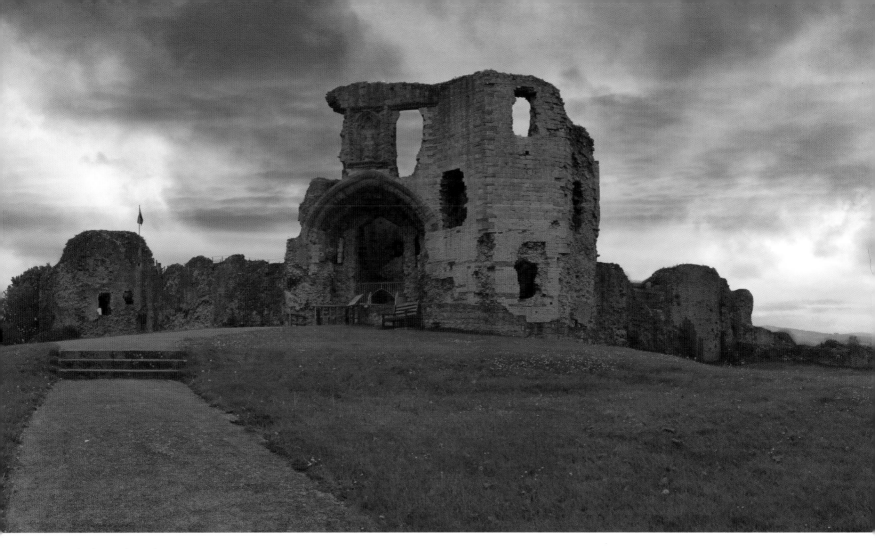

Denbigh Castle in the mist

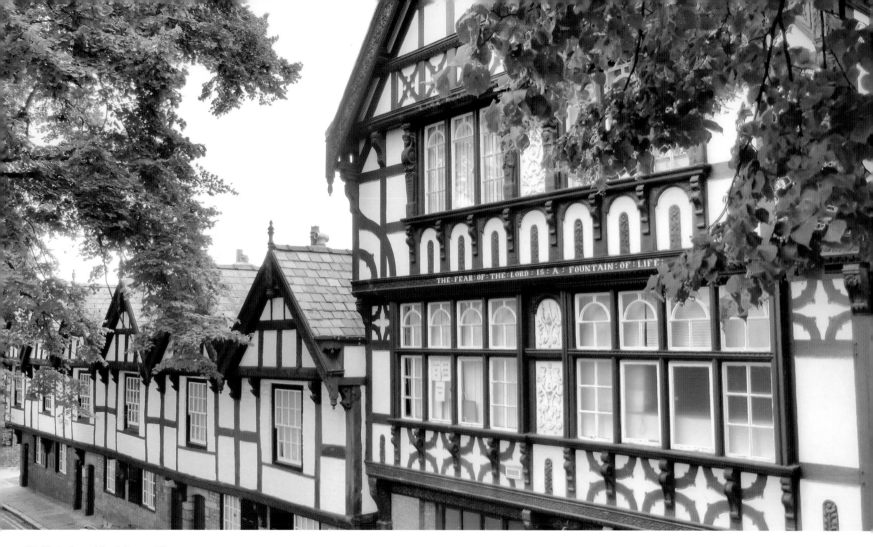

Half-timbered buildings, Chester

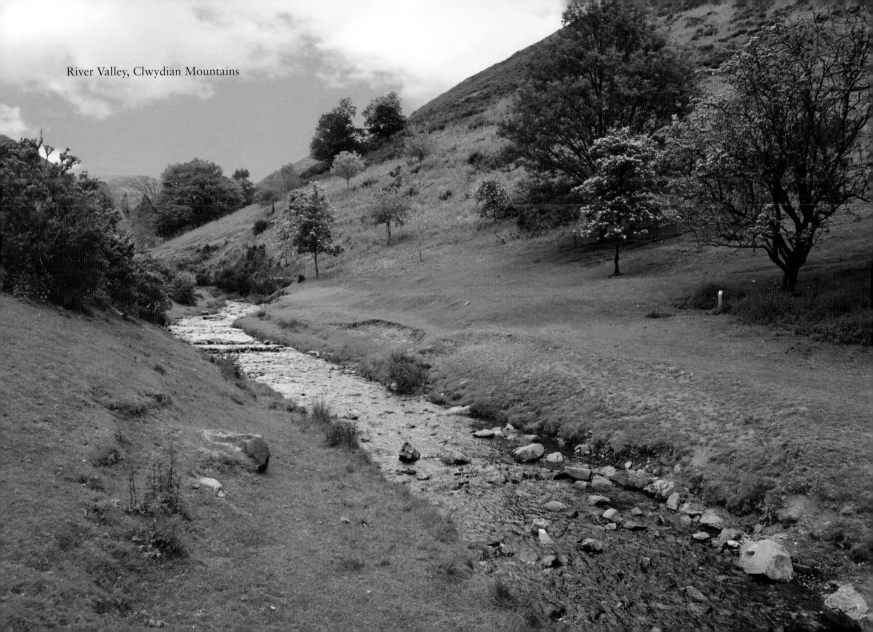

River Valley, Clwydian Mountains

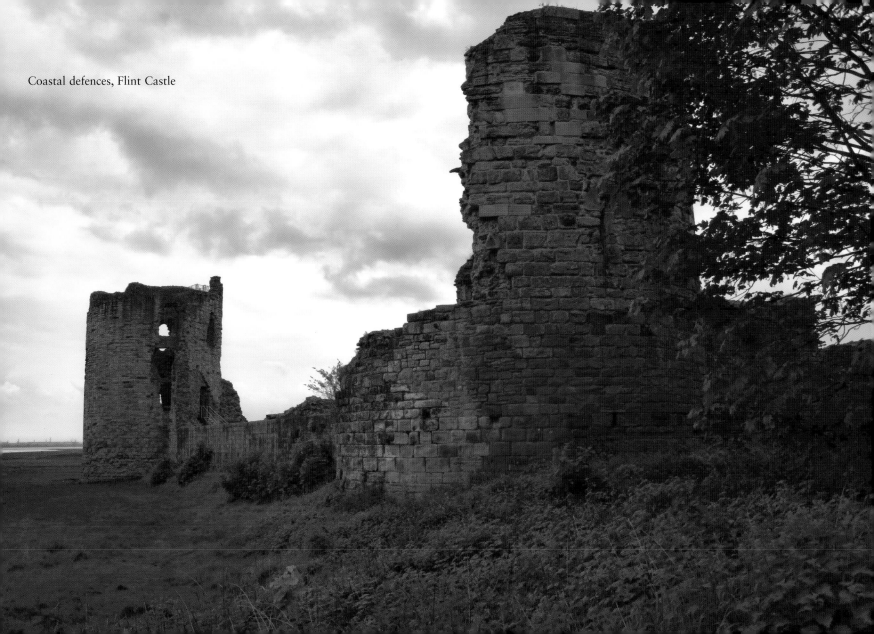

Coastal defences, Flint Castle

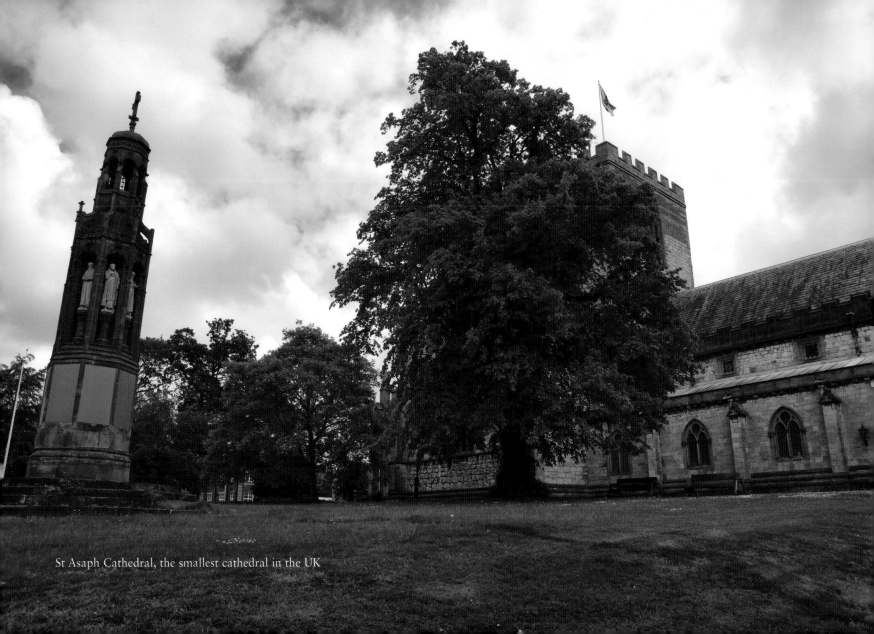

St Asaph Cathedral, the smallest cathedral in the UK

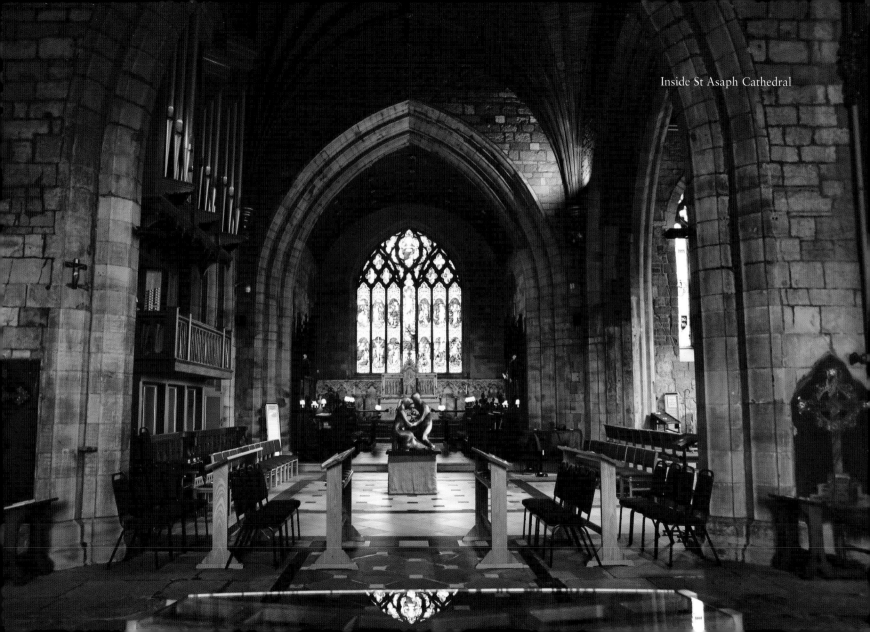

Inside St Asaph Cathedral

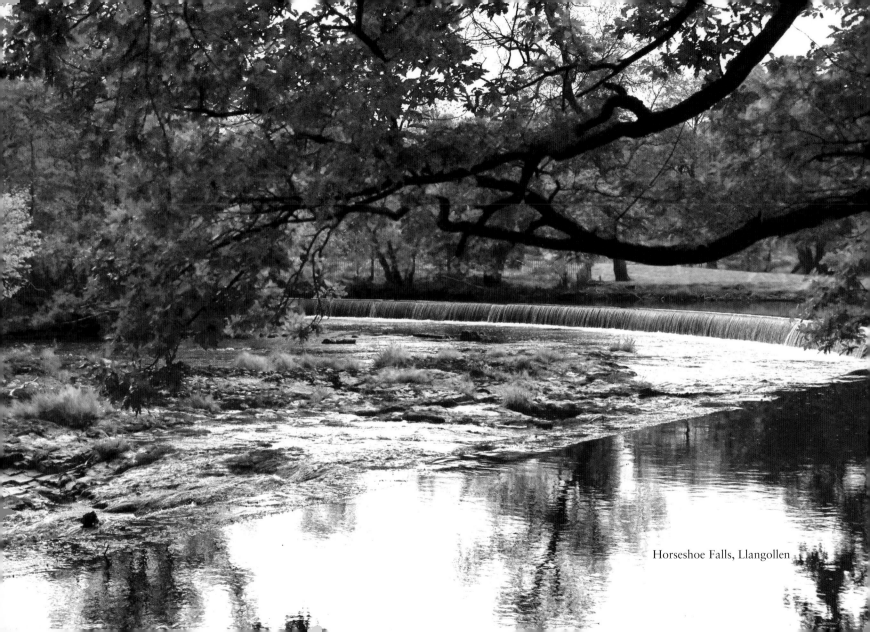

Horseshoe Falls, Llangollen

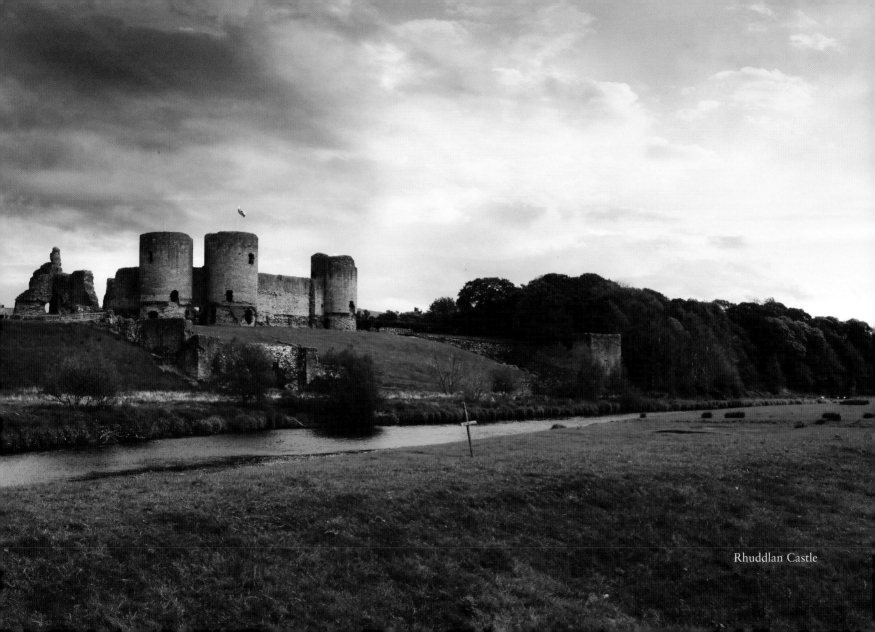

Rhuddlan Castle

Distant view, Clwydian Range

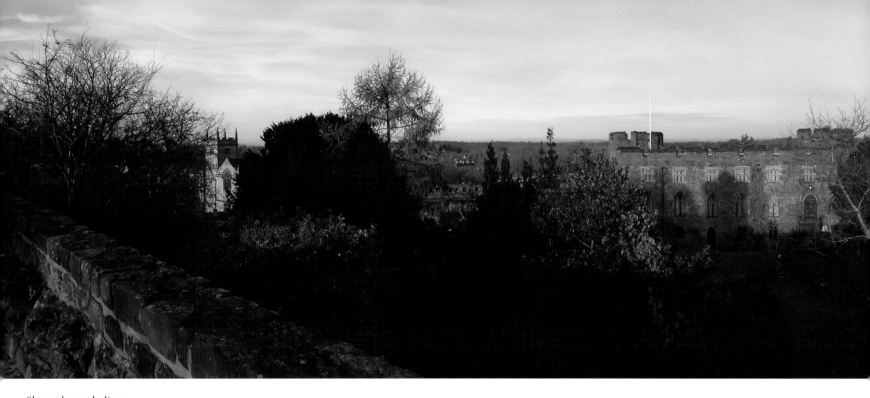

Shrewsbury skyline

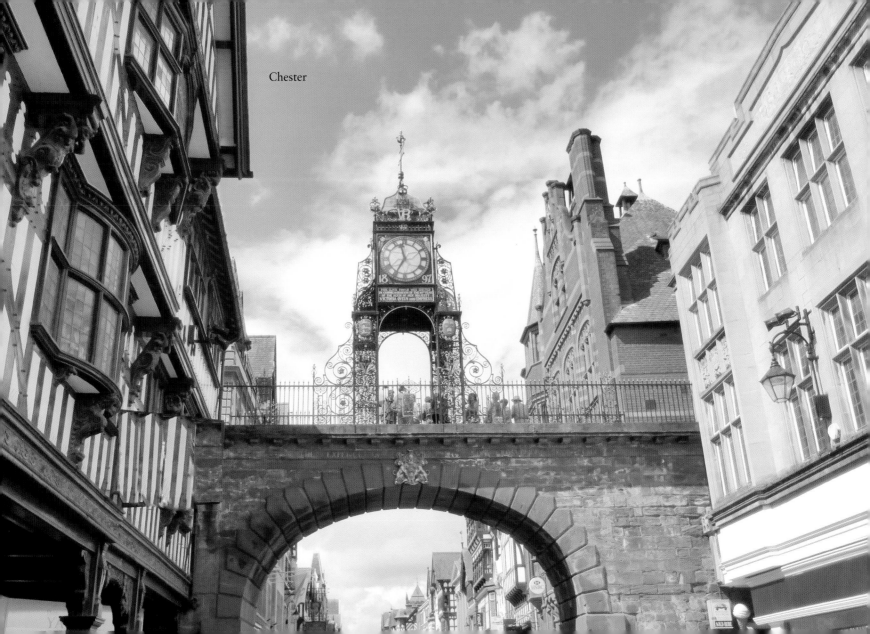

Chester

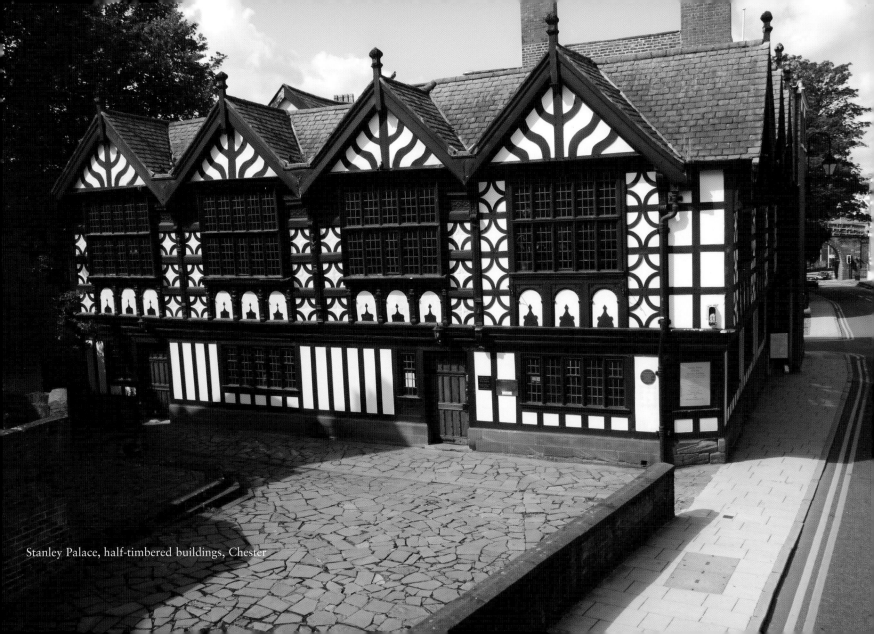
Stanley Palace, half-timbered buildings, Chester

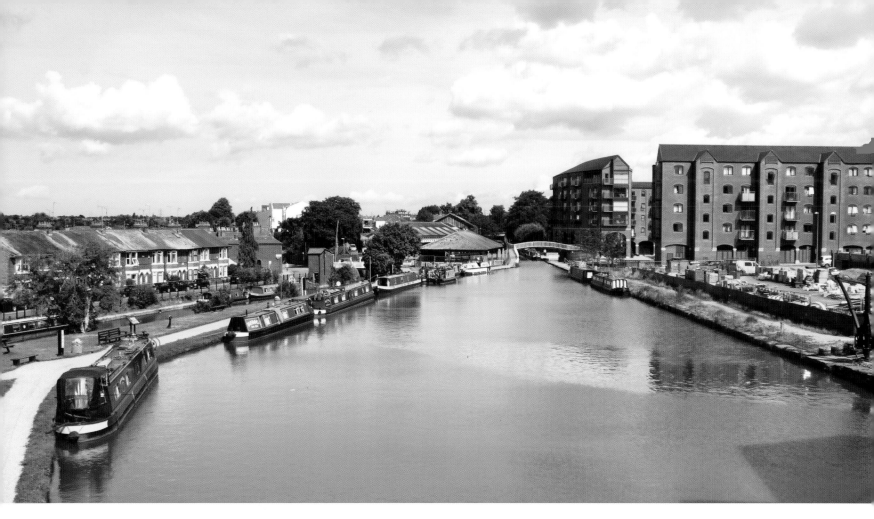

Chester Graving Dock and canal basin

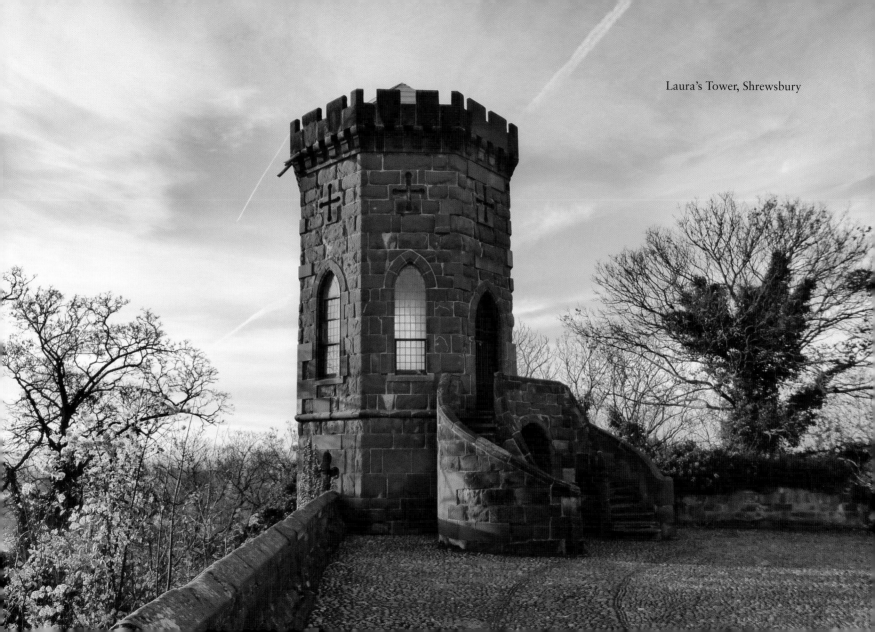

Laura's Tower, Shrewsbury

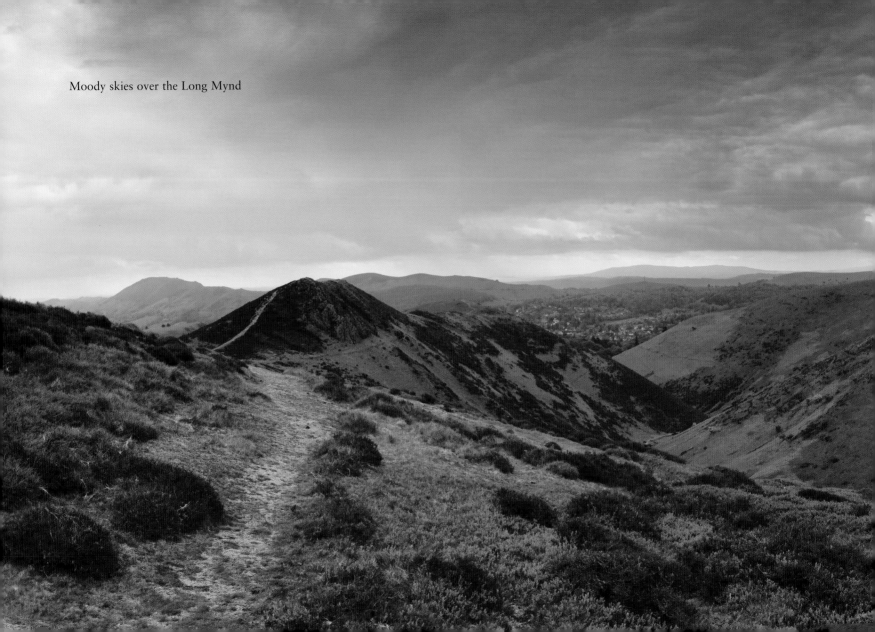

Moody skies over the Long Mynd

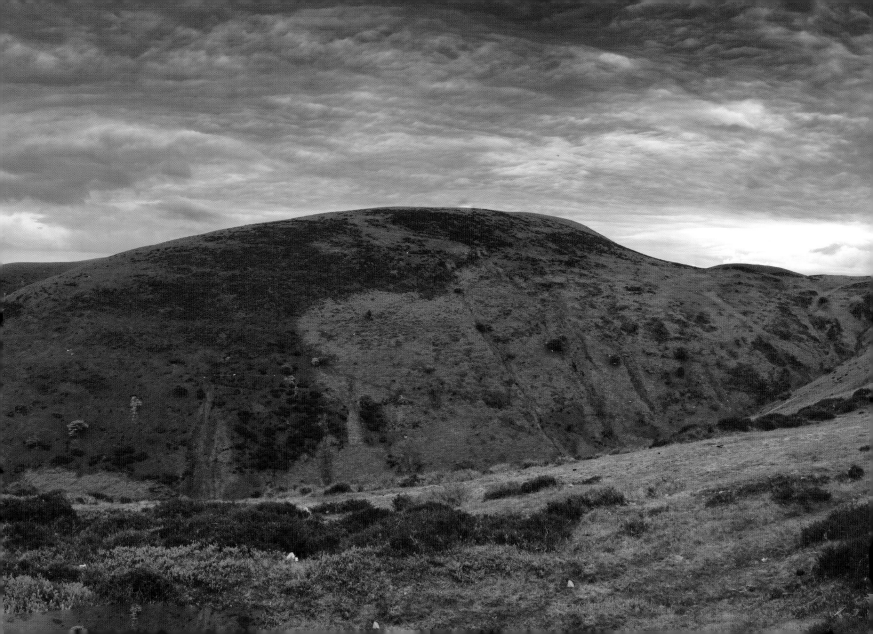

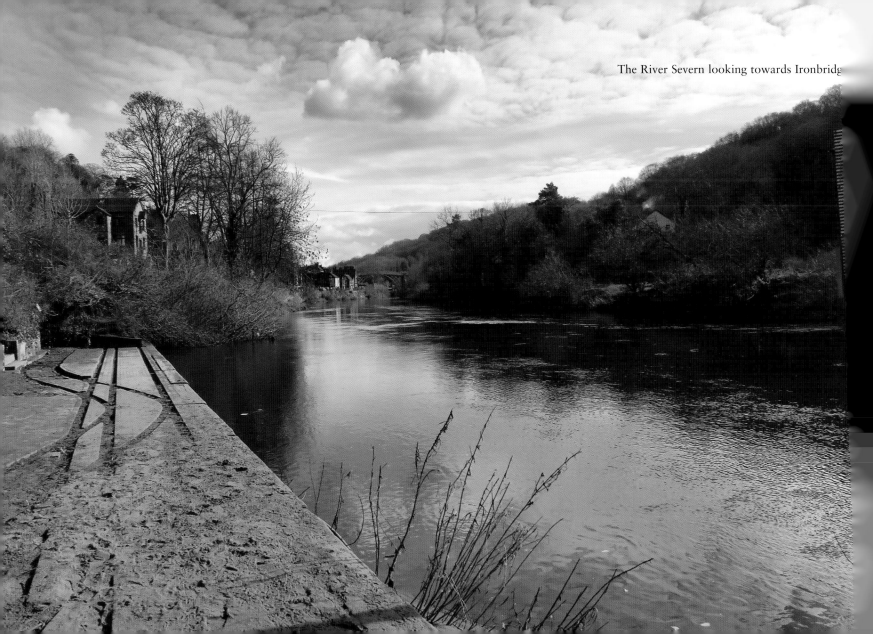

The River Severn looking towards Ironbridge

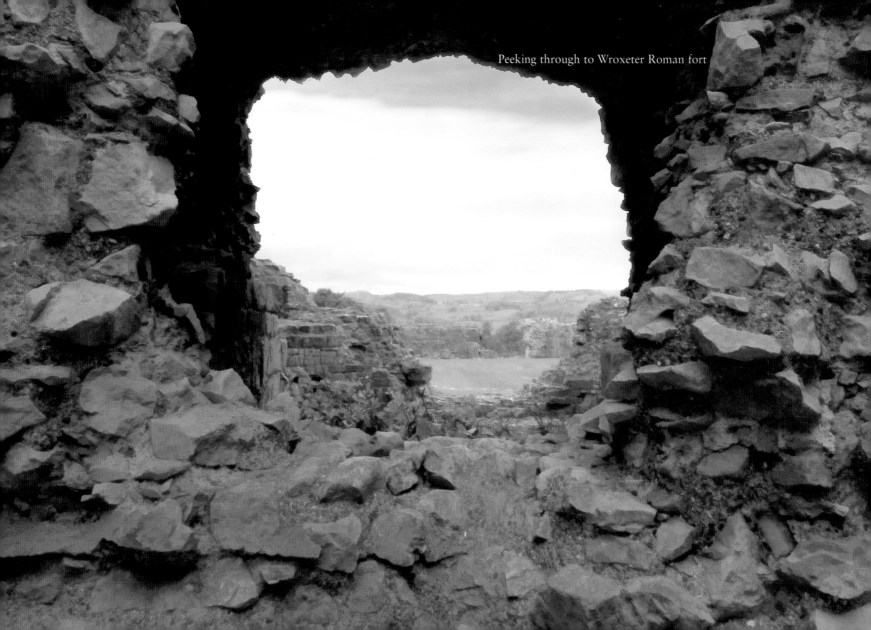

Peeking through to Wroxeter Roman fort

Reclamation, Ludlow Castle

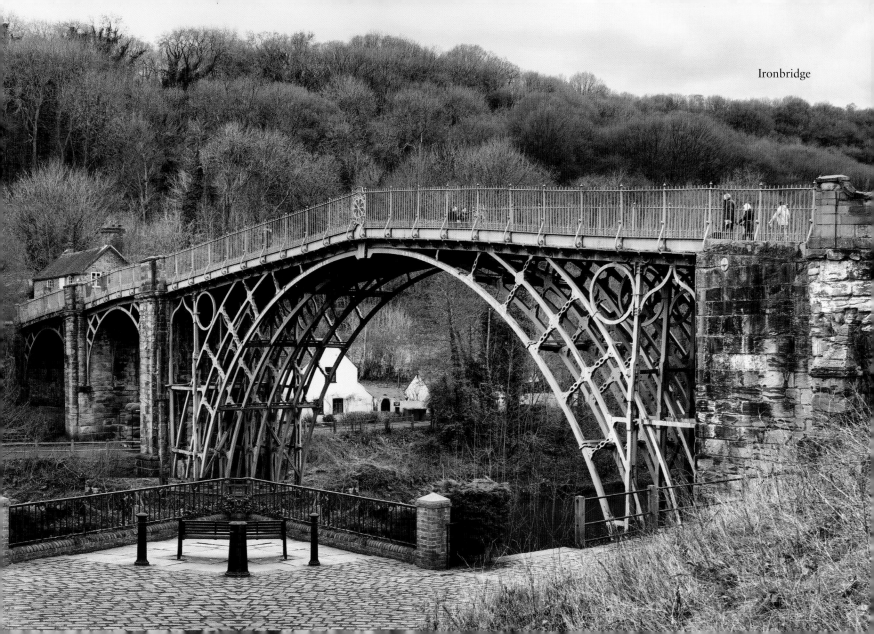

Ironbridge

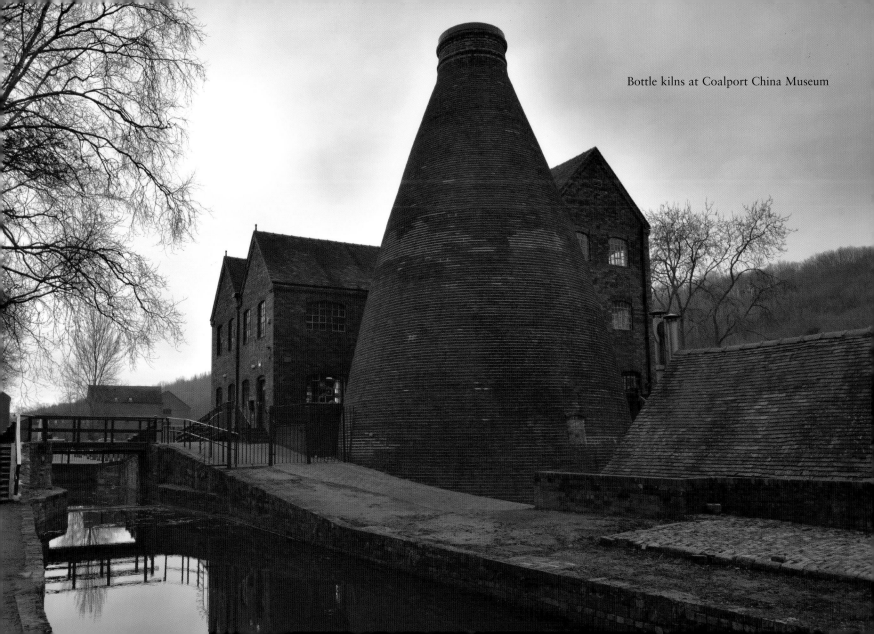

Bottle kilns at Coalport China Museum

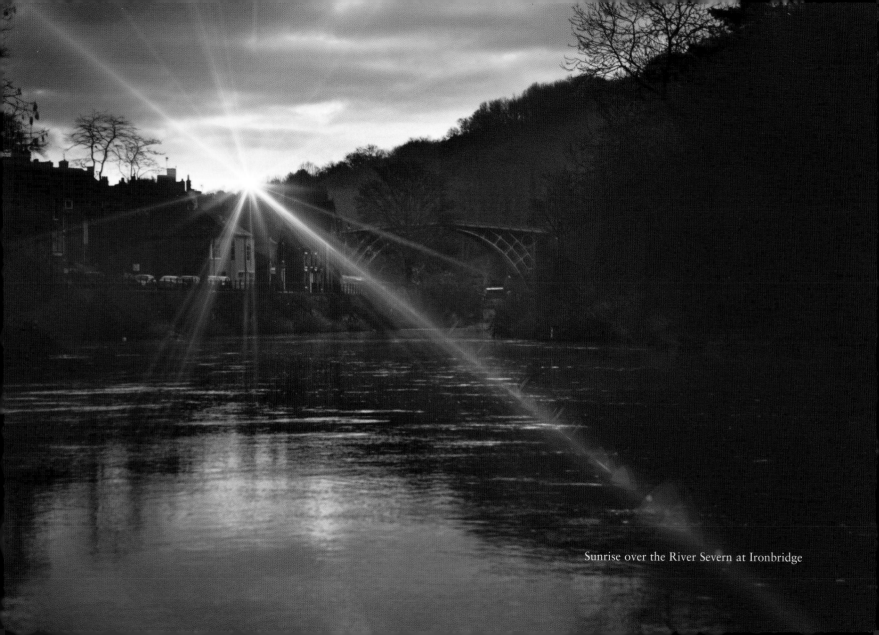

Sunrise over the River Severn at Ironbridge

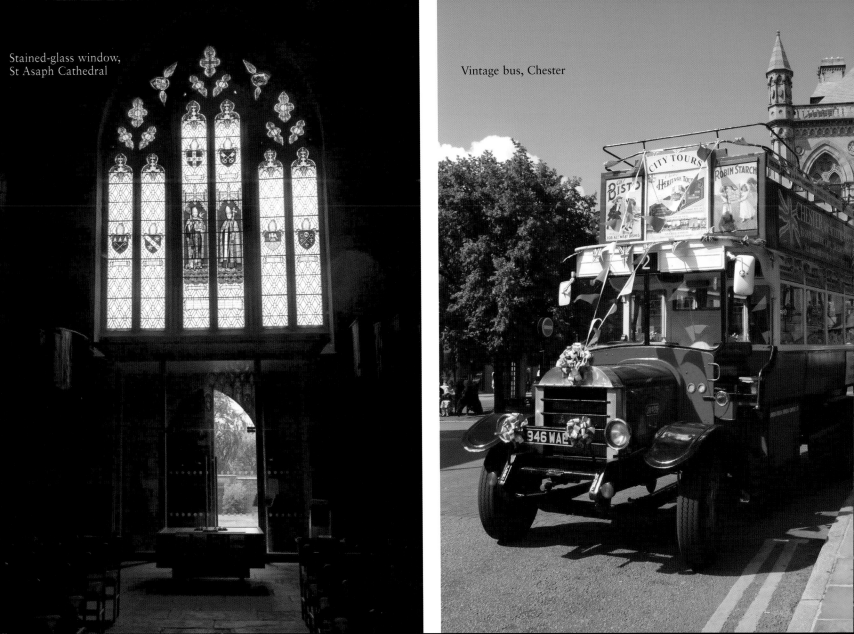

Stained-glass window,
St Asaph Cathedral

Vintage bus, Chester

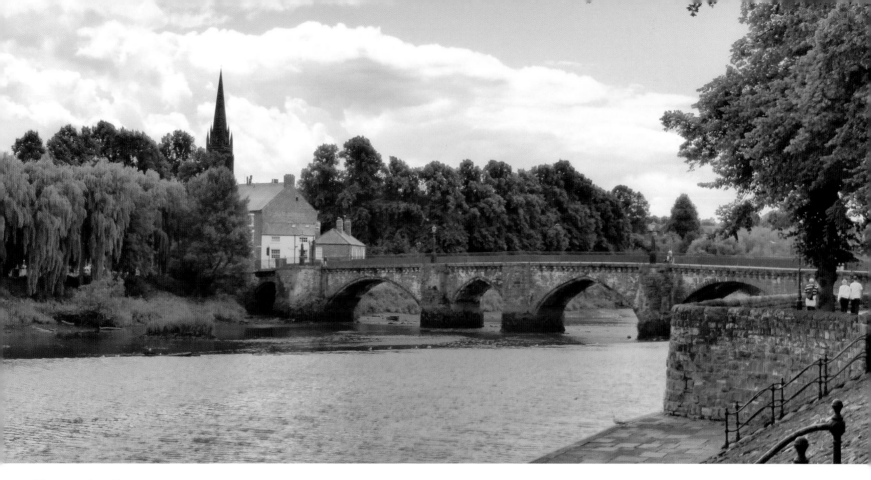

Old Dee Bridge, Chester

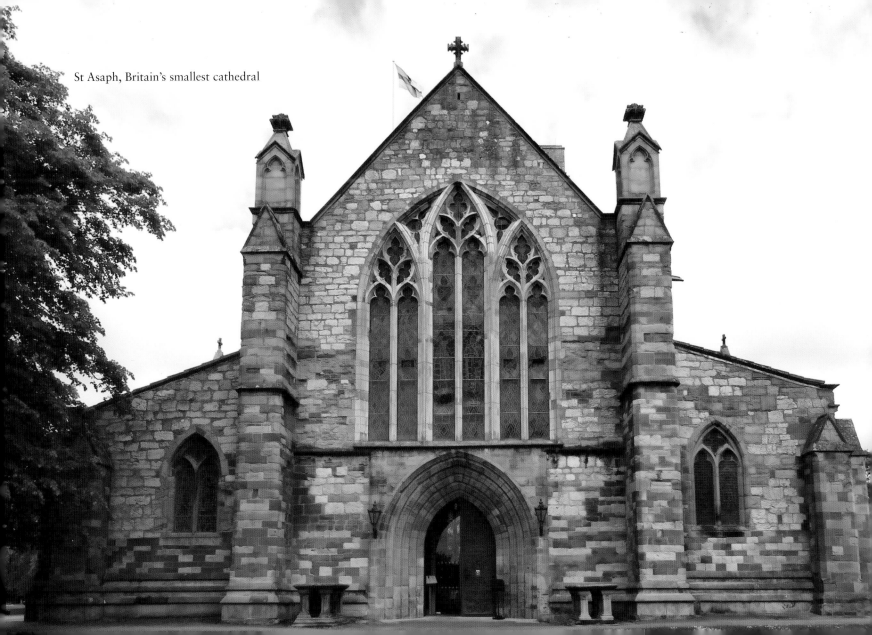

St Asaph, Britain's smallest cathedral

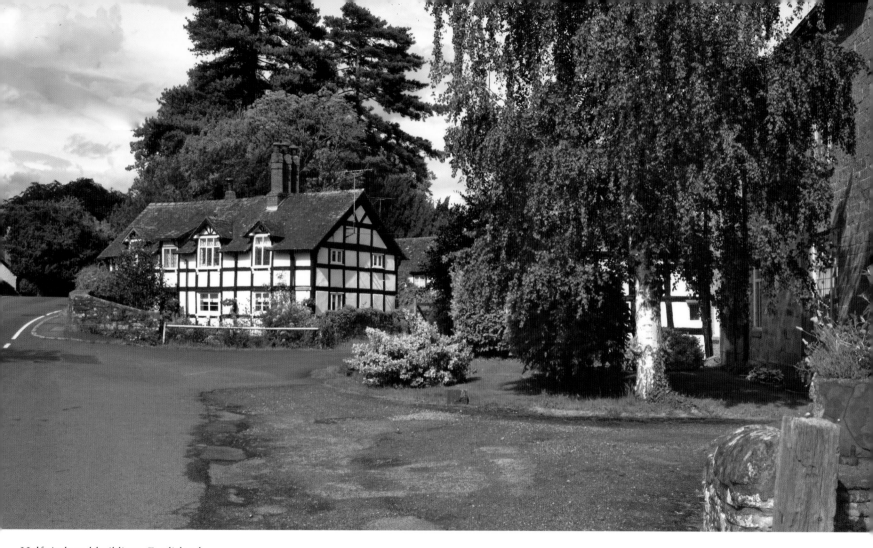

Half-timbered buildings, Eardisland

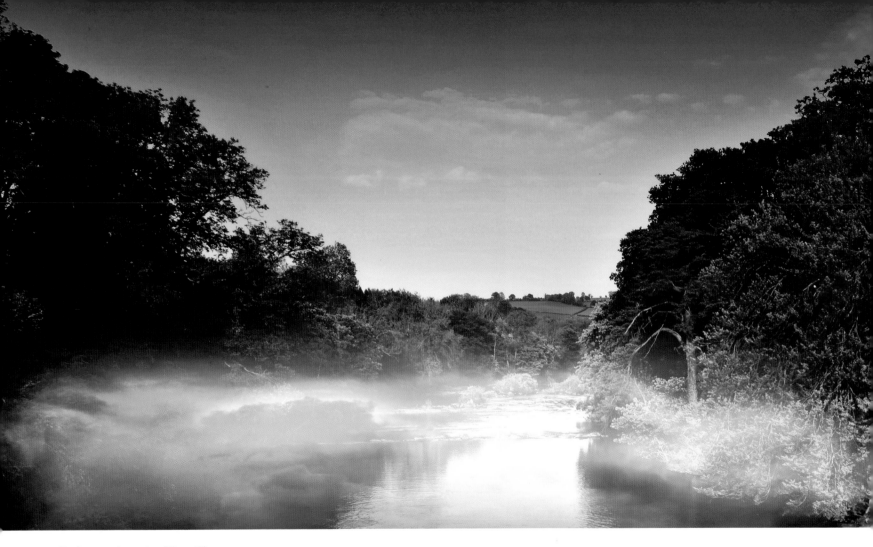

Early morning mist, River Clun

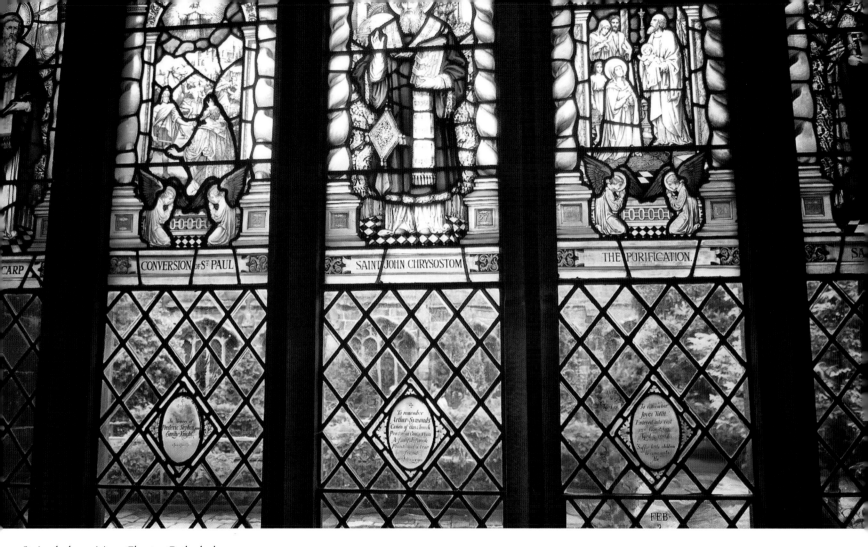

Stained-glass vision, Chester Cathedral

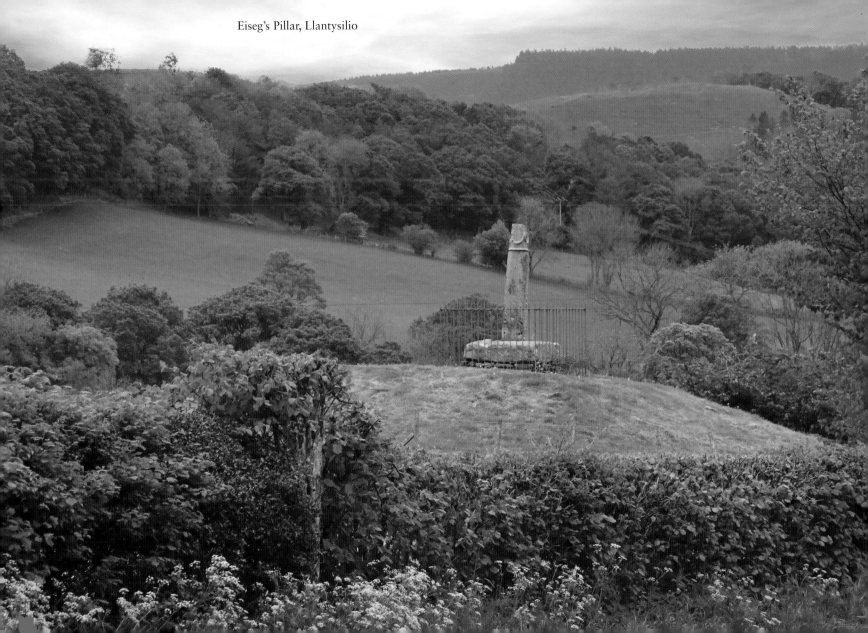

Eiseg's Pillar, Llantysilio

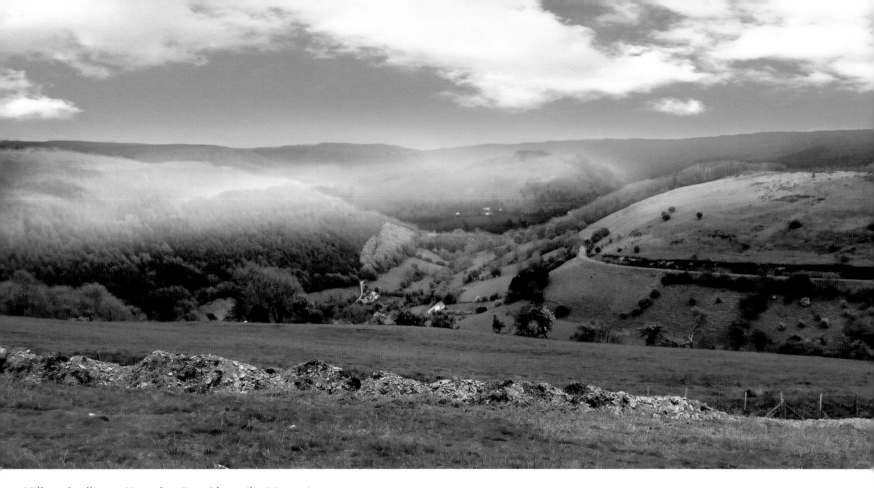

Hills and valleys at Horseshoe Pass, Llantysilio Mountain

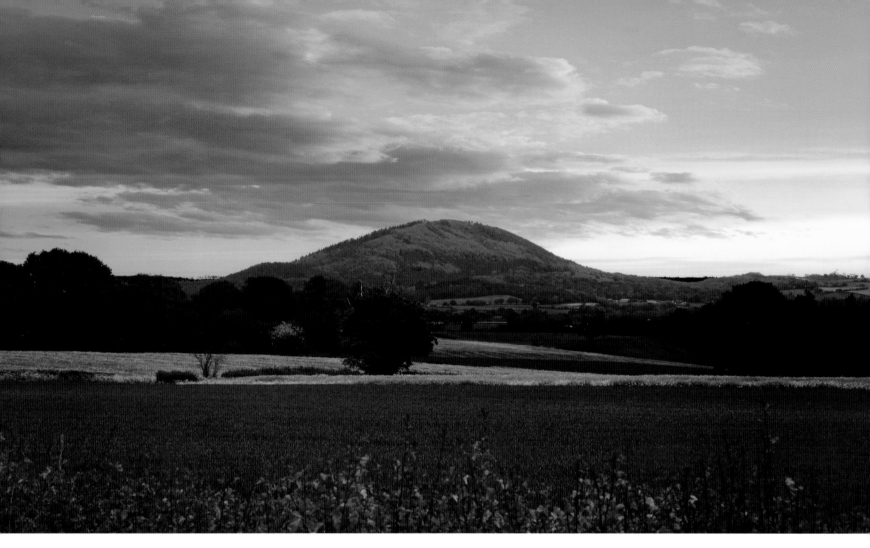

Last light over a small range near Llangollen

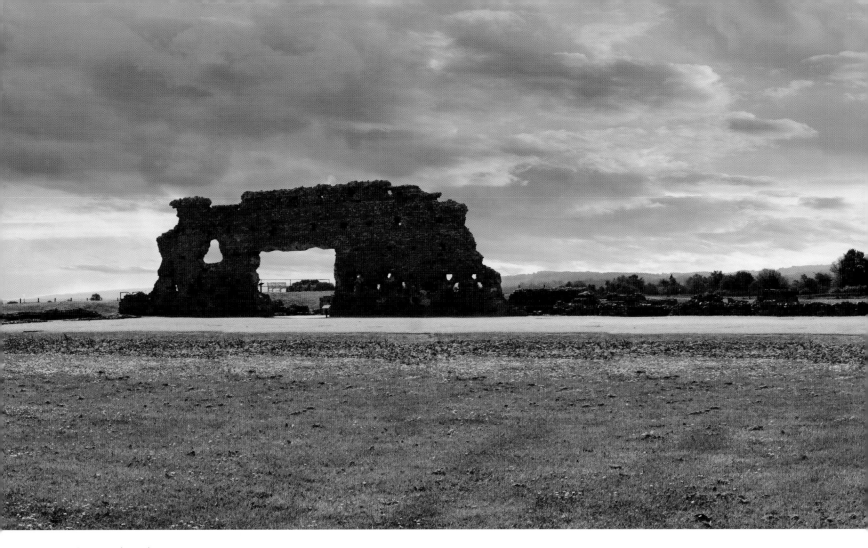

Wroxeter Roman city ruins

HEARTLANDS

Shropshire and Herefordshire form the core of the Welsh Marches. Ludlow and Hereford have key places in history where power has been held from time to time. Ludlow in particular has possibly the best example of a fortified manor at Stokesay and is well worth a visit, including the church and the site of a battleground.

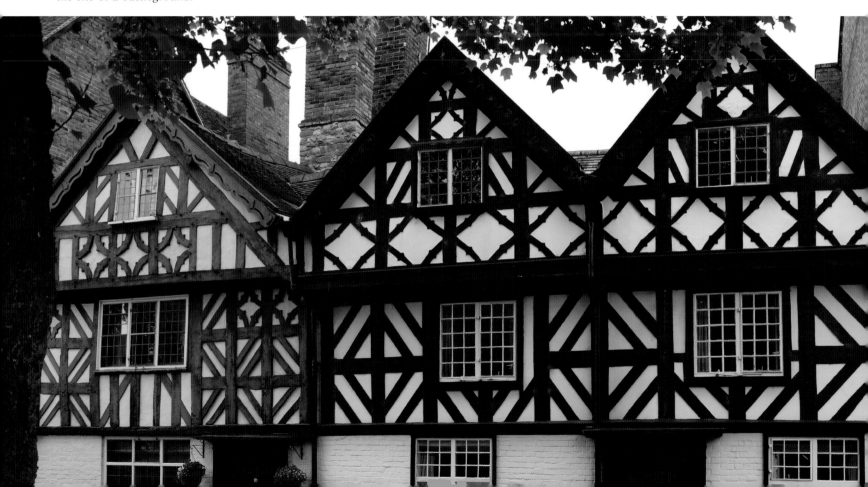

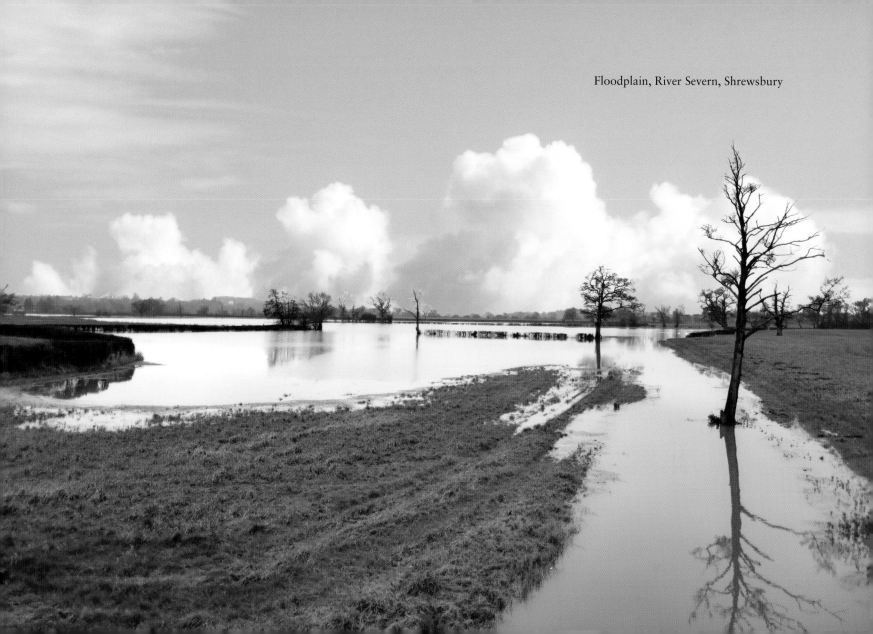

Floodplain, River Severn, Shrewsbury

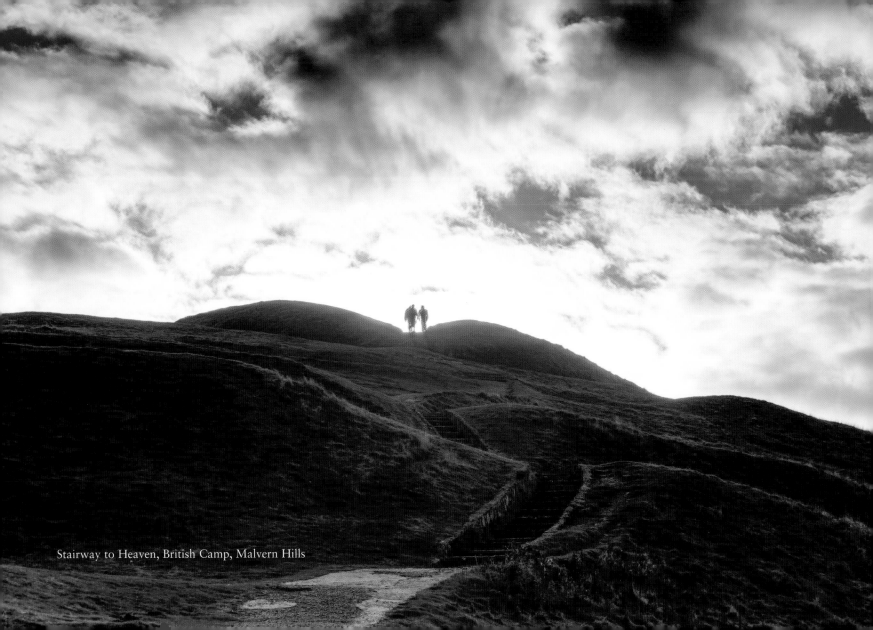

Stairway to Heaven, British Camp, Malvern Hills

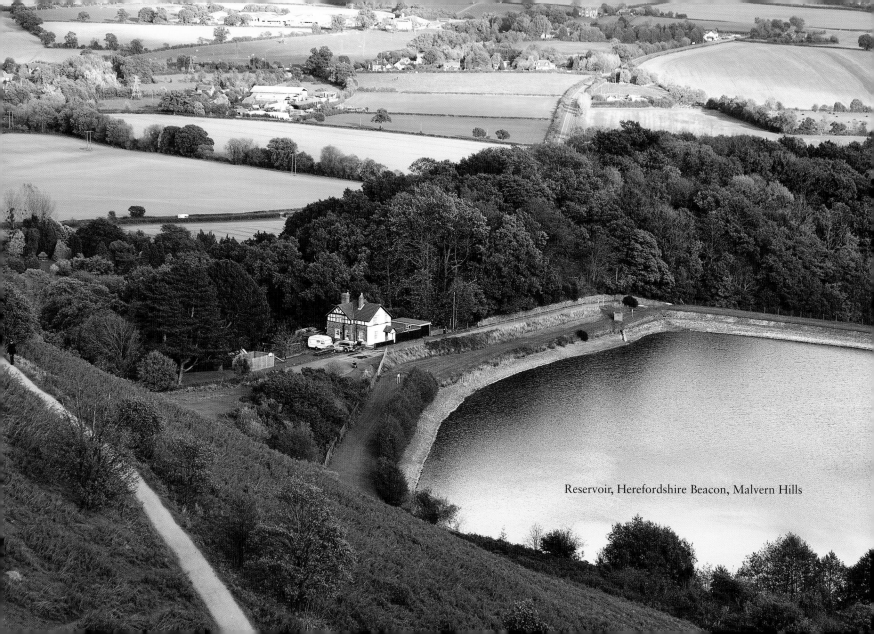

Reservoir, Herefordshire Beacon, Malvern Hills

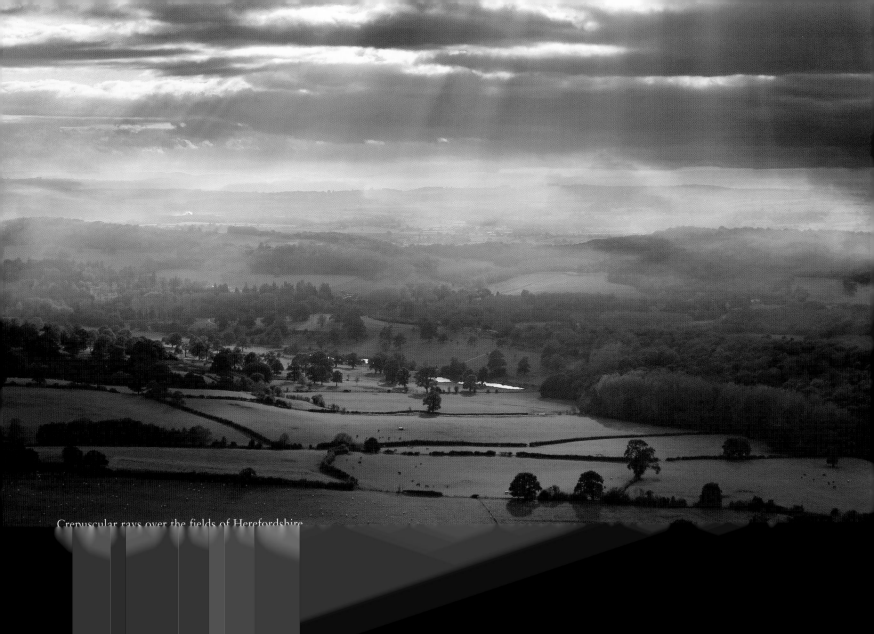

Crepuscular rays over the fields of Herefordshire

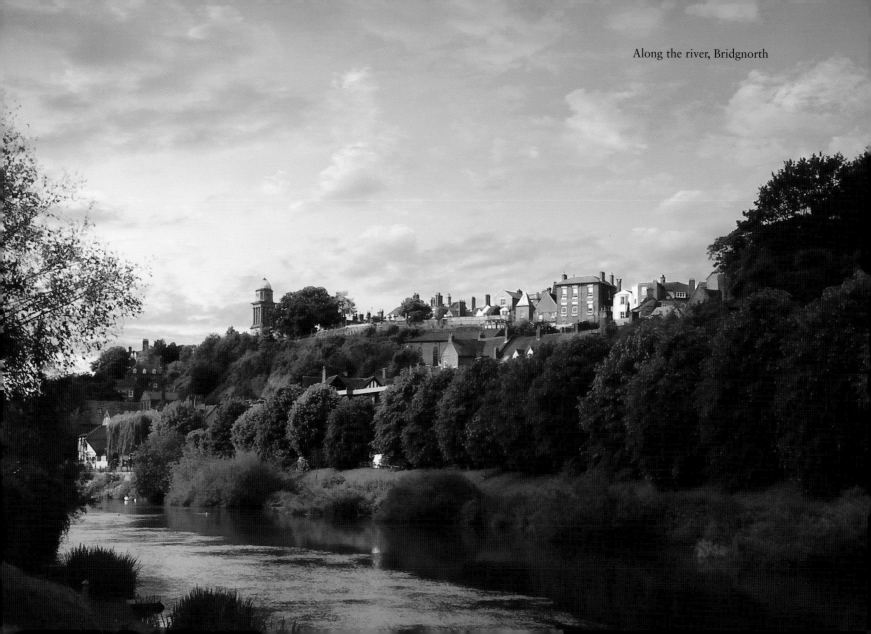

Along the river, Bridgnorth

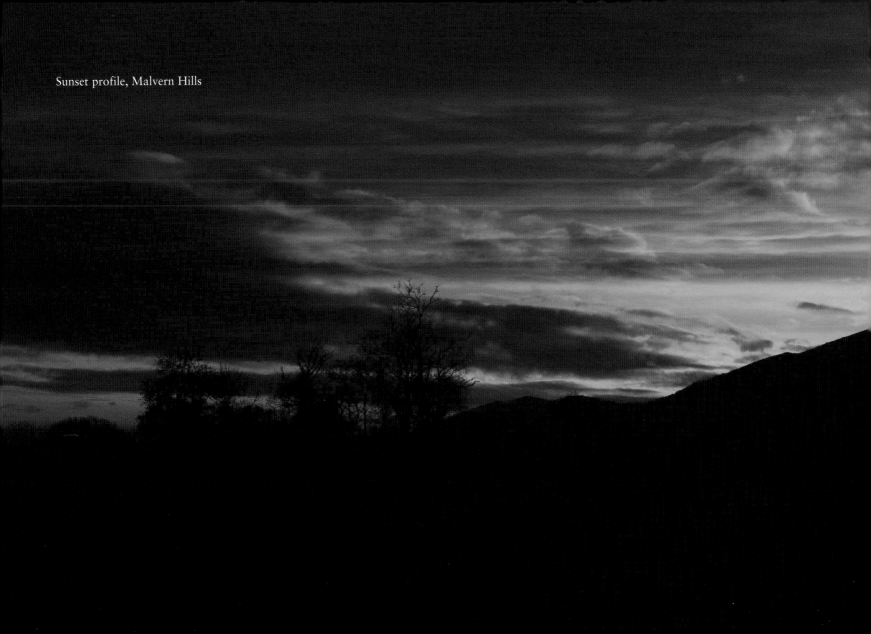

Sunset profile, Malvern Hills

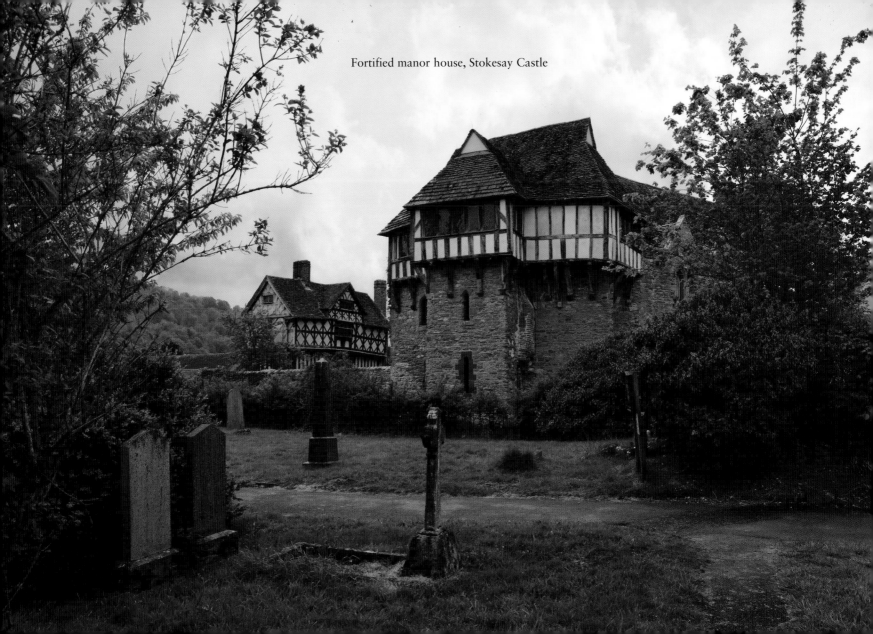
Fortified manor house, Stokesay Castle

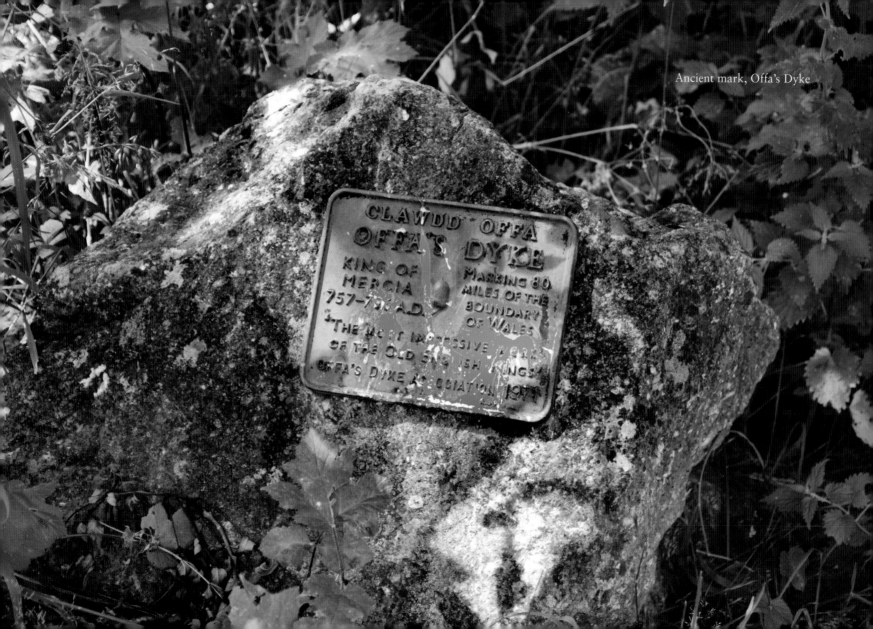

Ancient mark, Offa's Dyke

CLAWDD OFFA
OFFA'S DYKE

KING OF
MERCIA
757-796 A.D.

MARKING 80
MILES OF THE
BOUNDARY
OF WALES

"THE MOST IMPRESSIVE WORK
OF THE OLD ENGLISH KINGS"

OFFA'S DYKE ASSOCIATION 1971

Canopy, Clee Hills

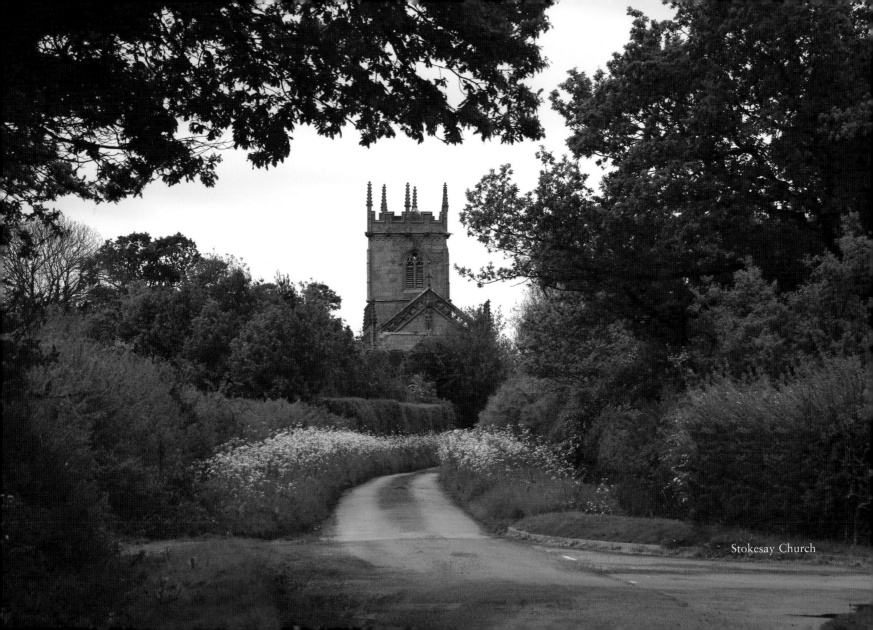
Stokesay Church

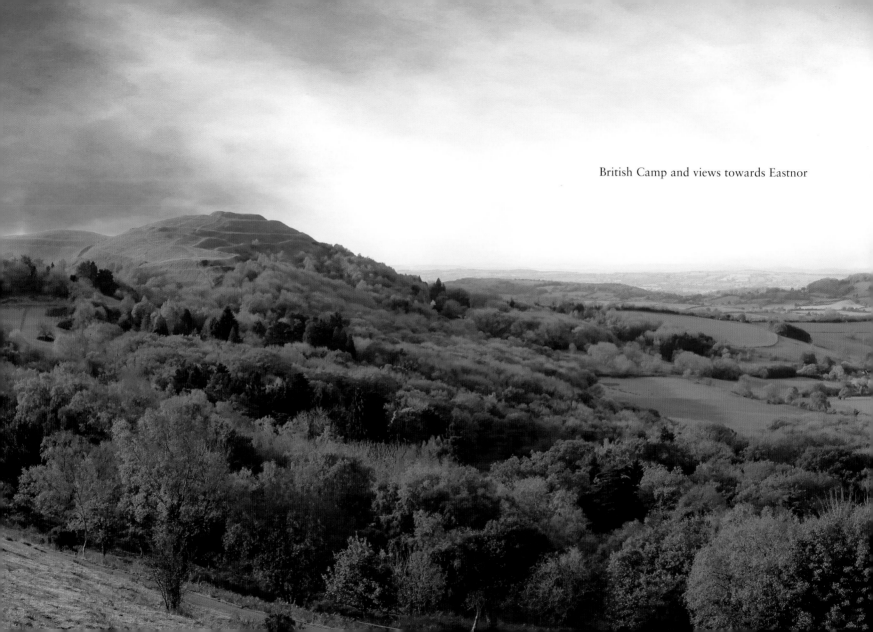

British Camp and views towards Eastnor

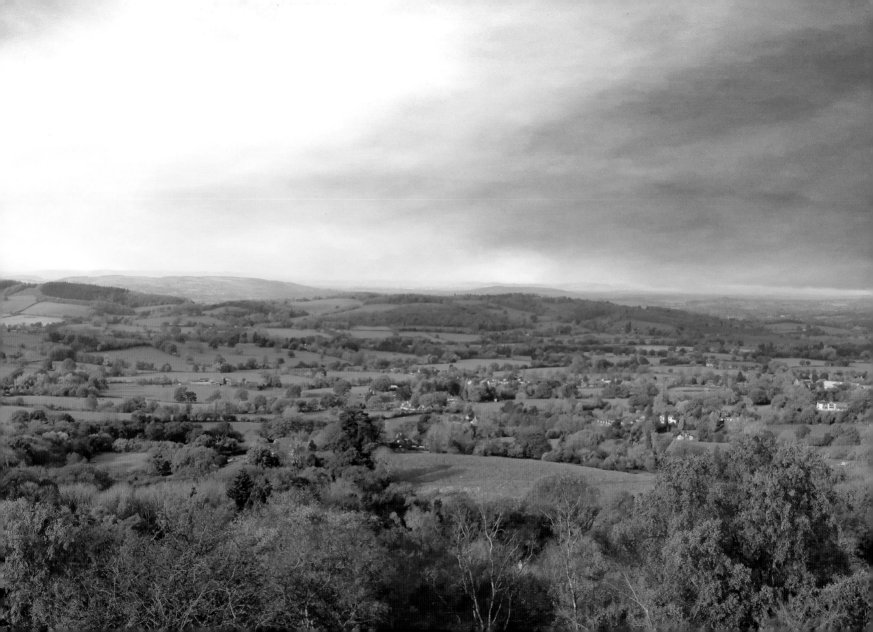

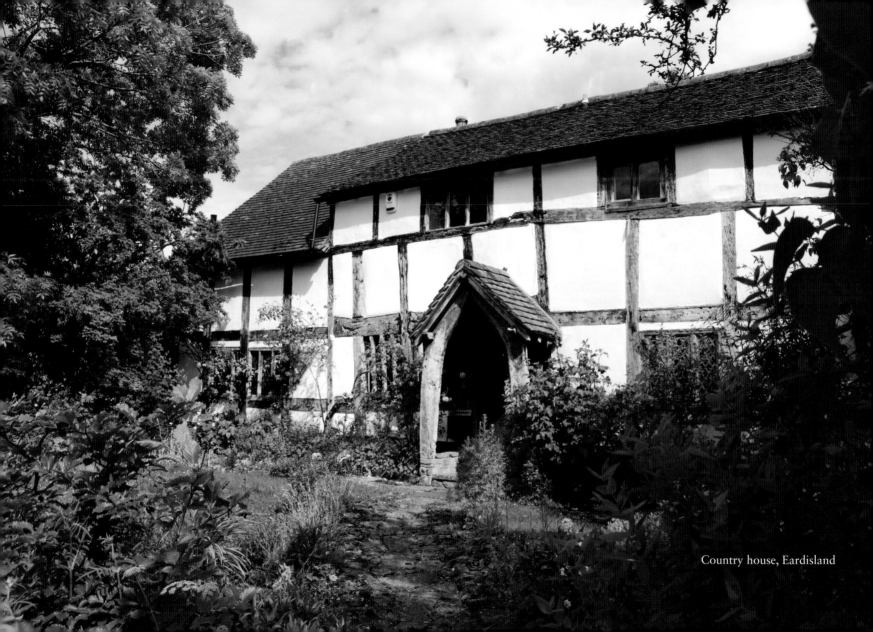

Country house, Eardisland

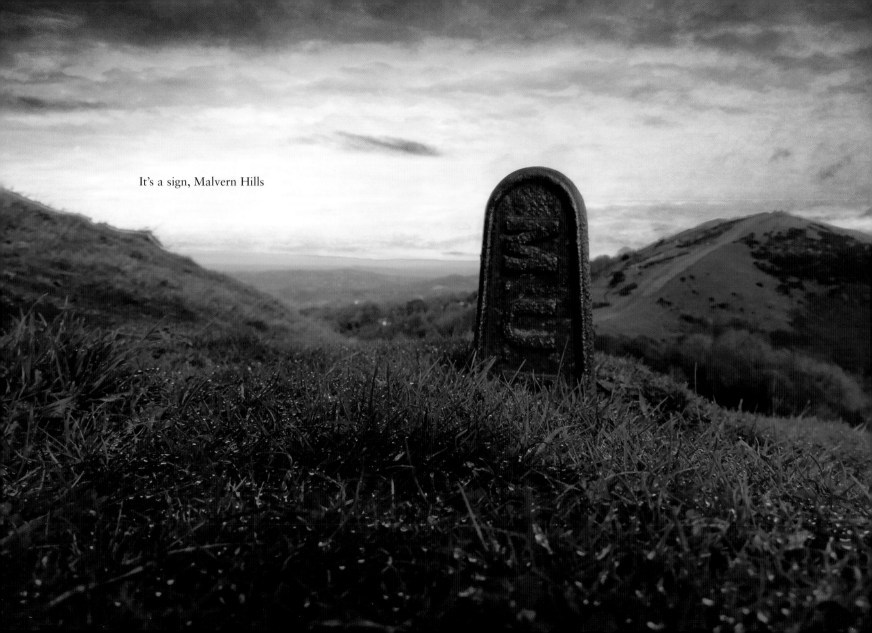

It's a sign, Malvern Hills

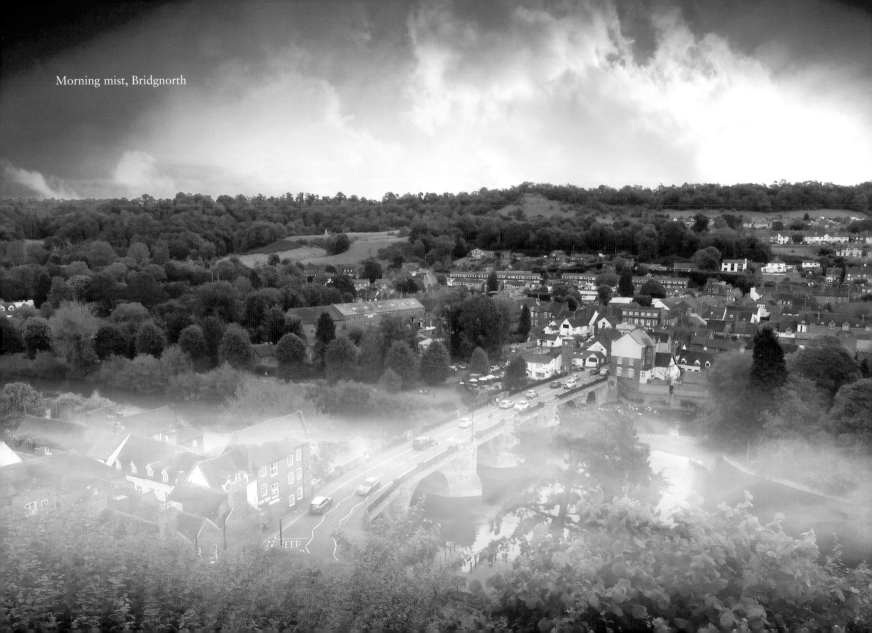

Morning mist, Bridgnorth

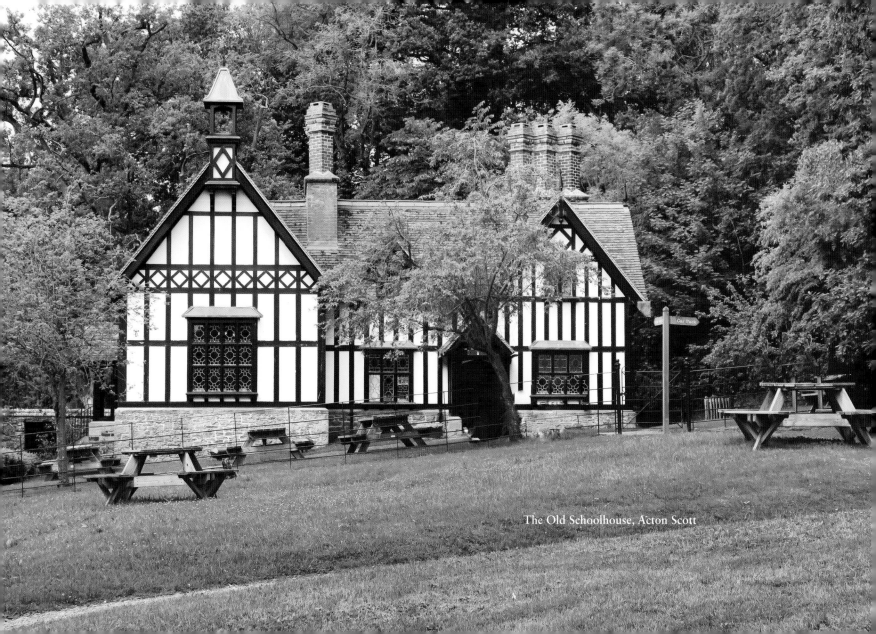

The Old Schoolhouse, Acton Scott

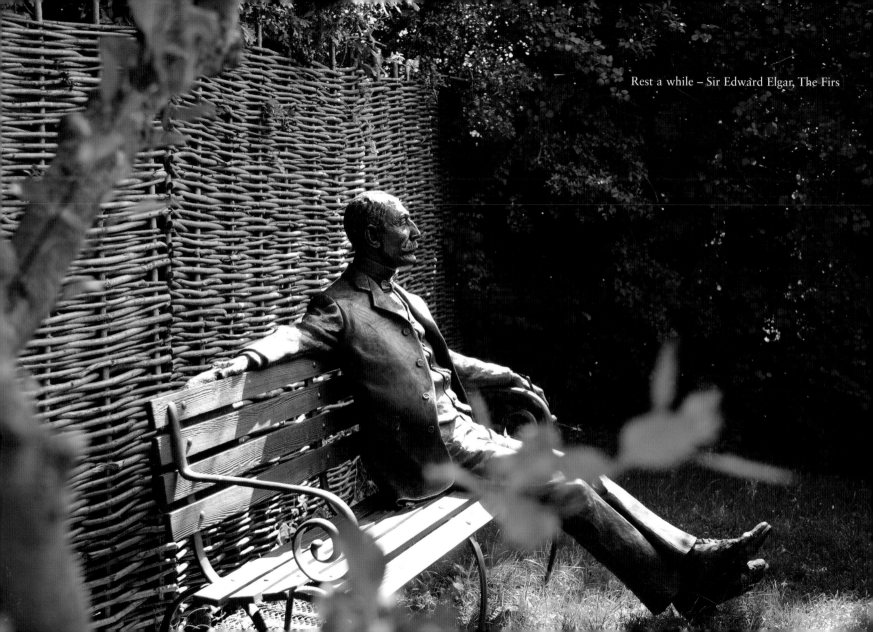

Rest a while – Sir Edward Elgar, The Firs

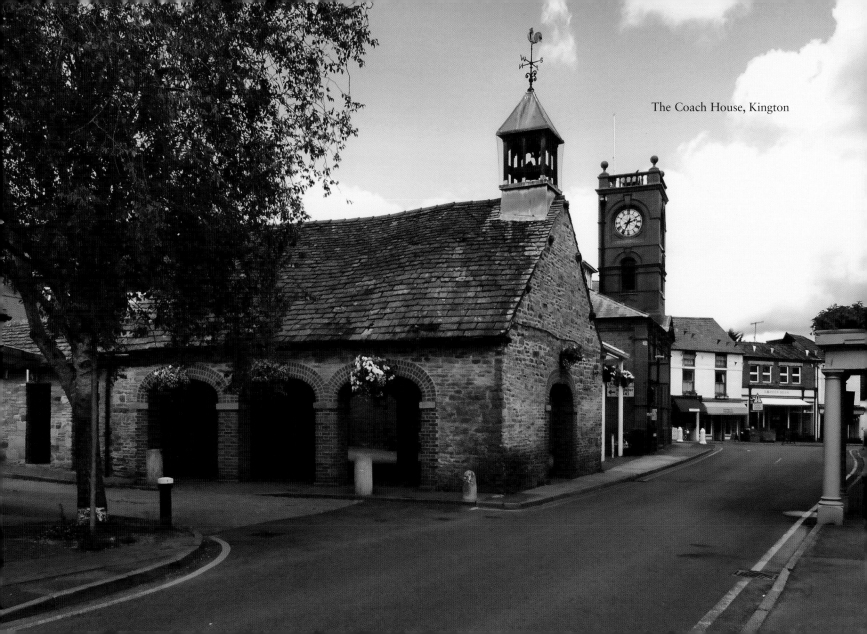

The Coach House, Kington

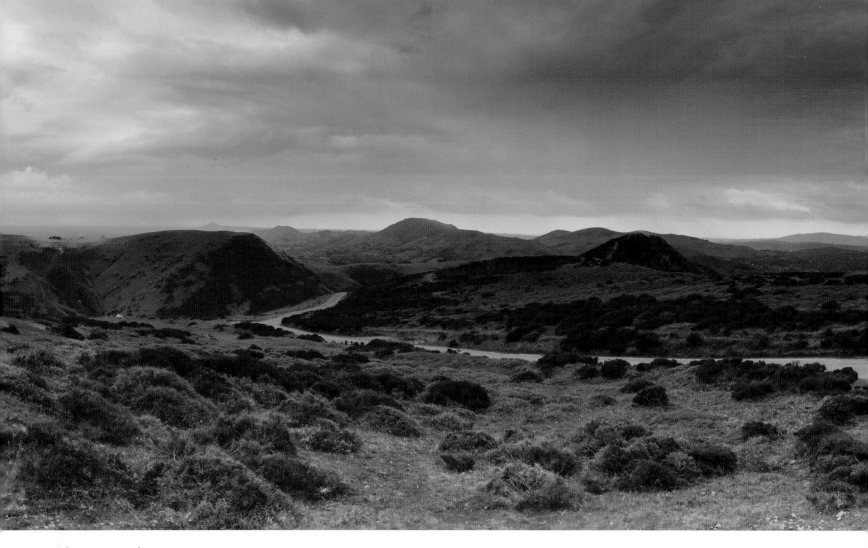

The Long Mynd

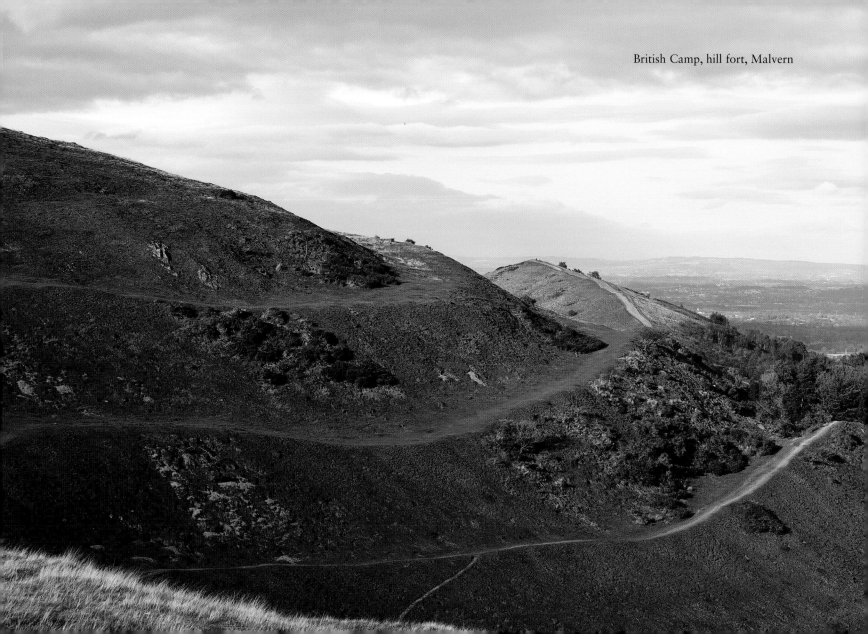
British Camp, hill fort, Malvern

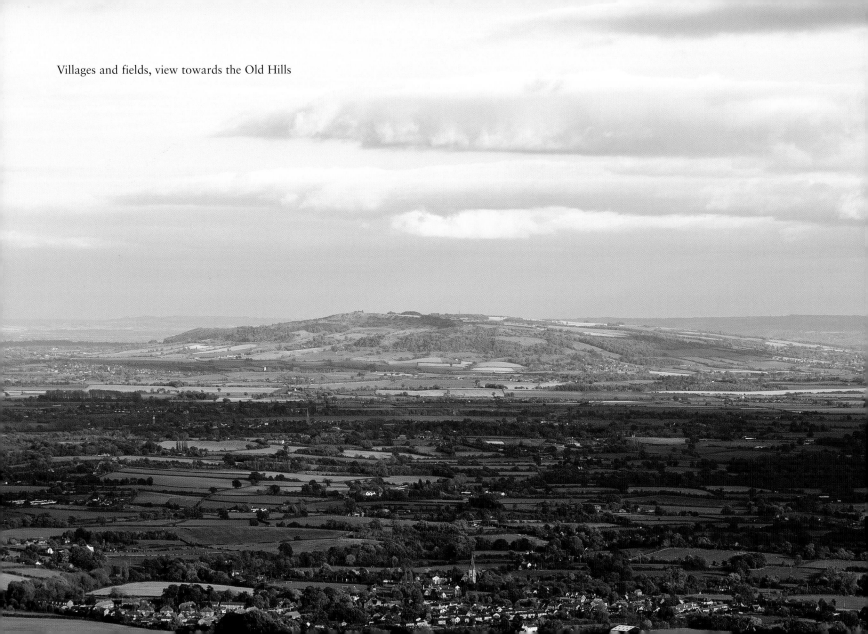

Villages and fields, view towards the Old Hills

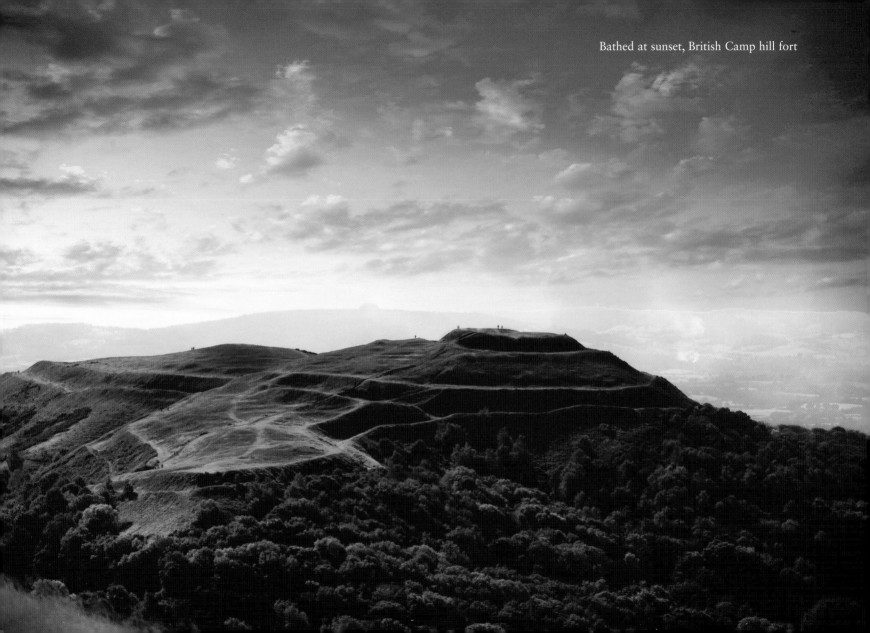

Bathed at sunset, British Camp hill fort

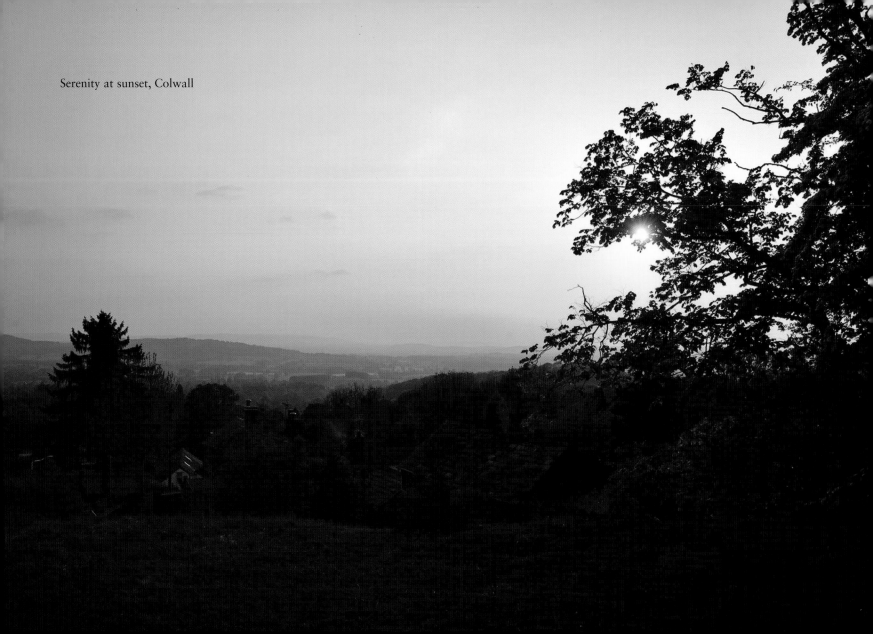

Serenity at sunset, Colwall

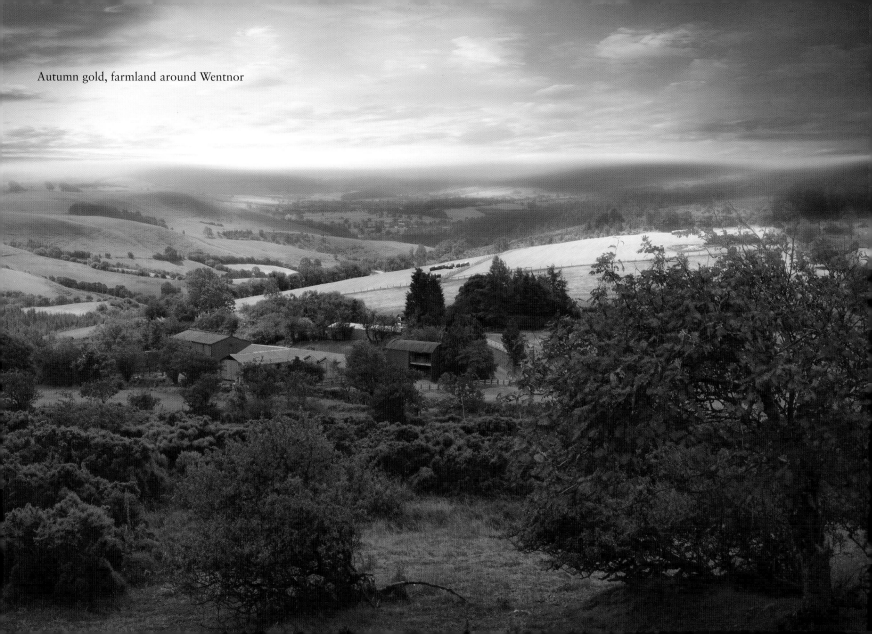

Autumn gold, farmland around Wentnor

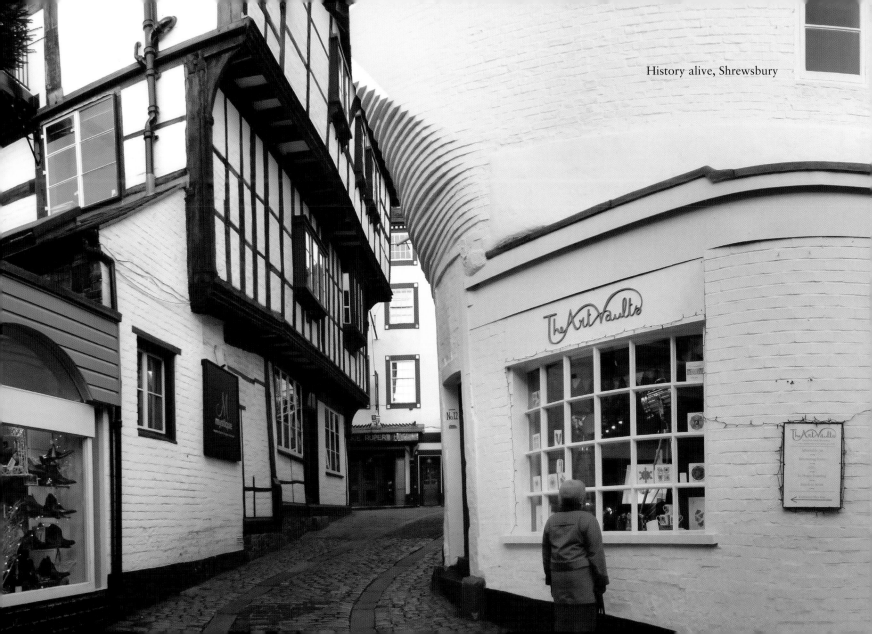

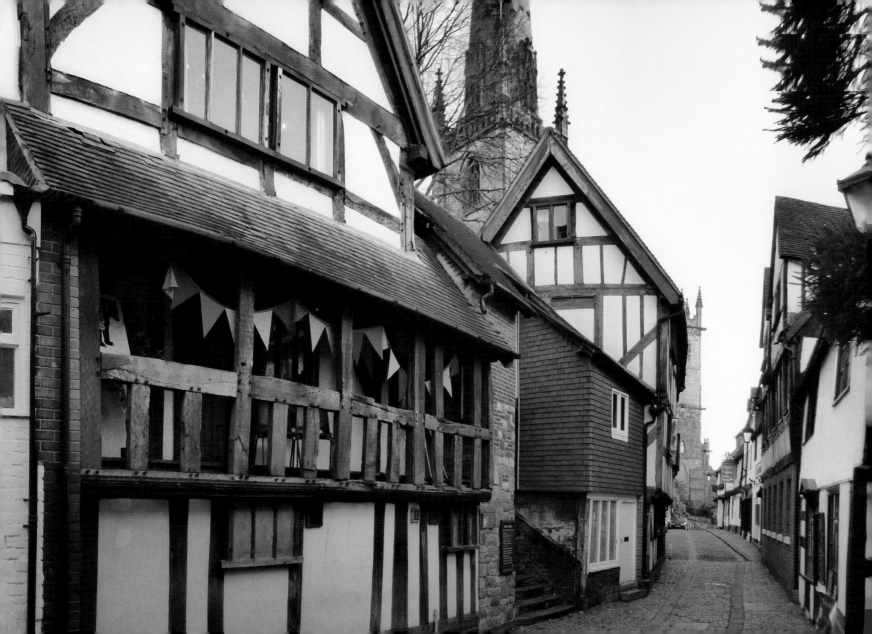

View from the ridge, Clee Hills

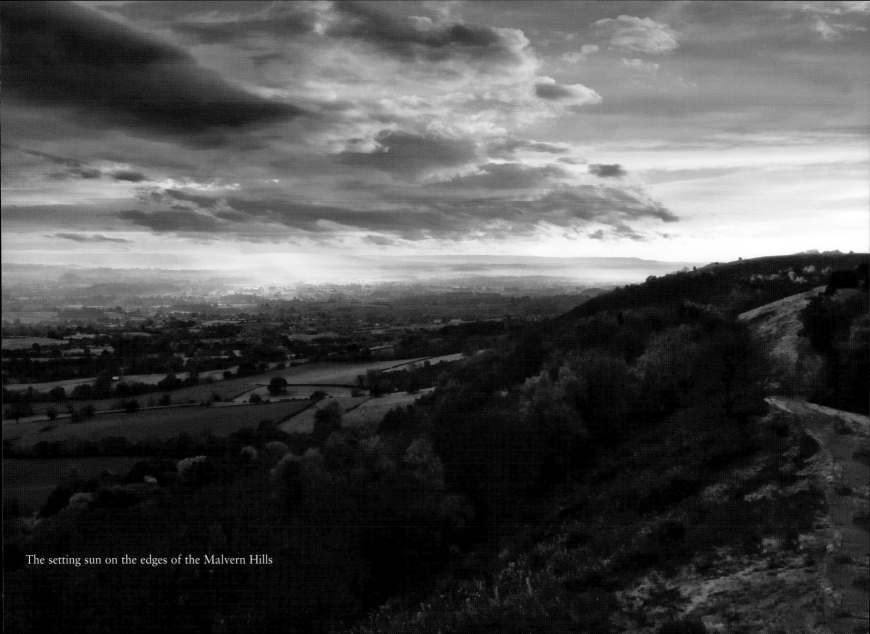

The setting sun on the edges of the Malvern Hills

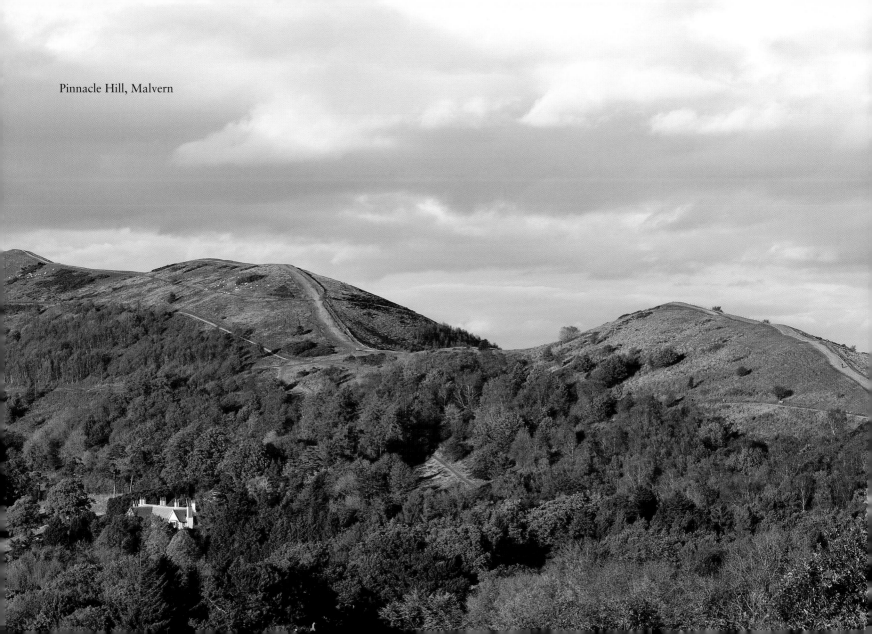

Pinnacle Hill, Malvern

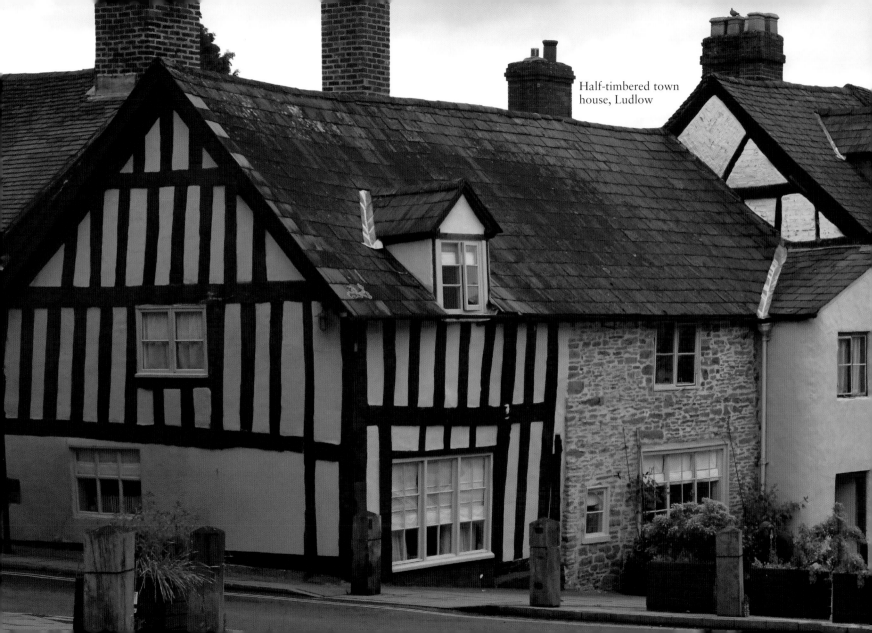

Half-timbered town
house, Ludlow

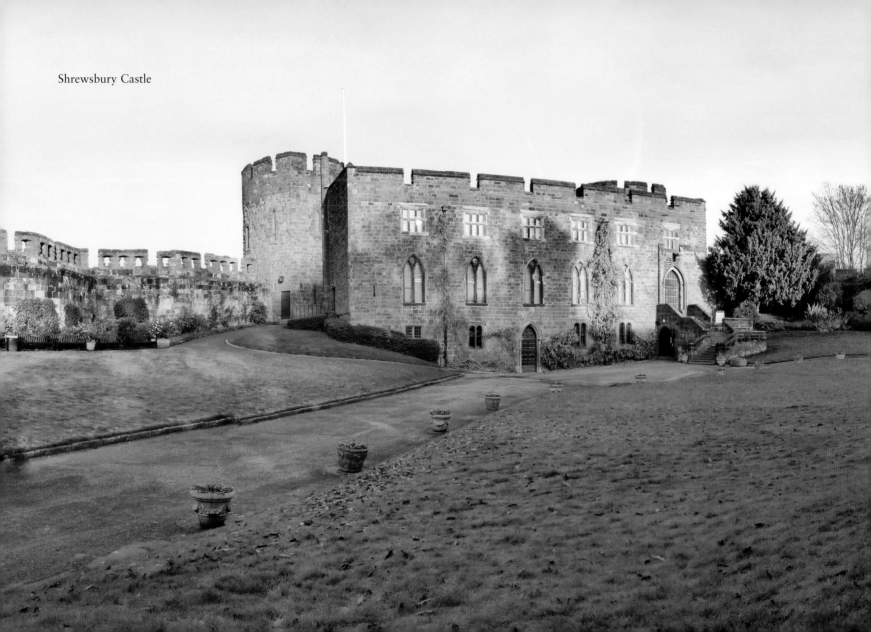

Shrewsbury Castle

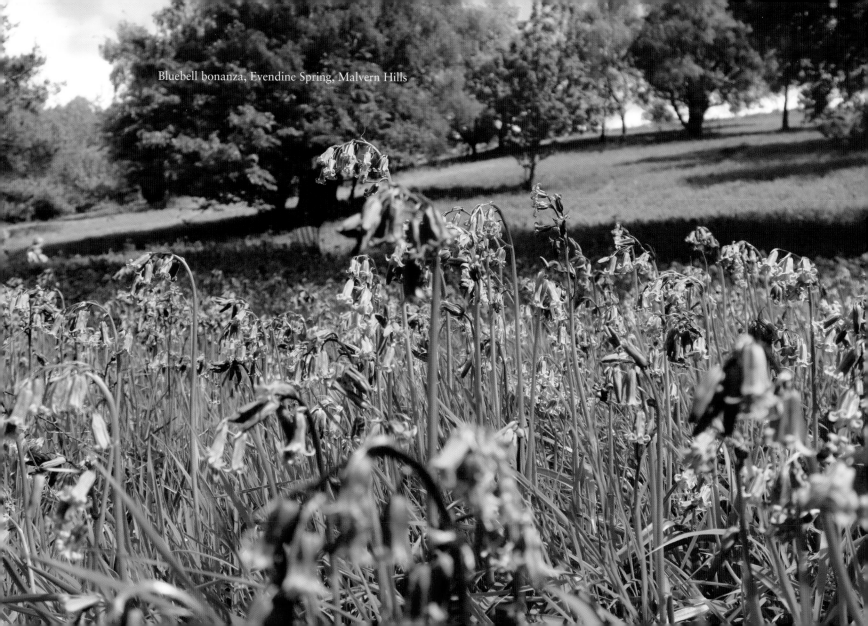

Bluebell bonanza, Evendine Spring, Malvern Hills

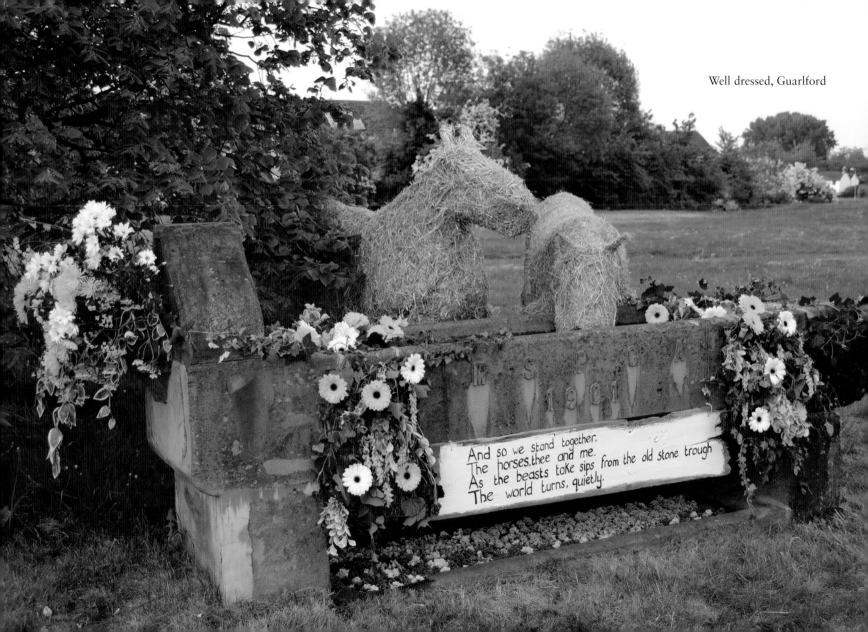

Well dressed, Guarlford

M S P C A
1901

And so we stand together,
The horses, thee and me.
As the beasts take sips from the old stone trough
The world turns, quietly.

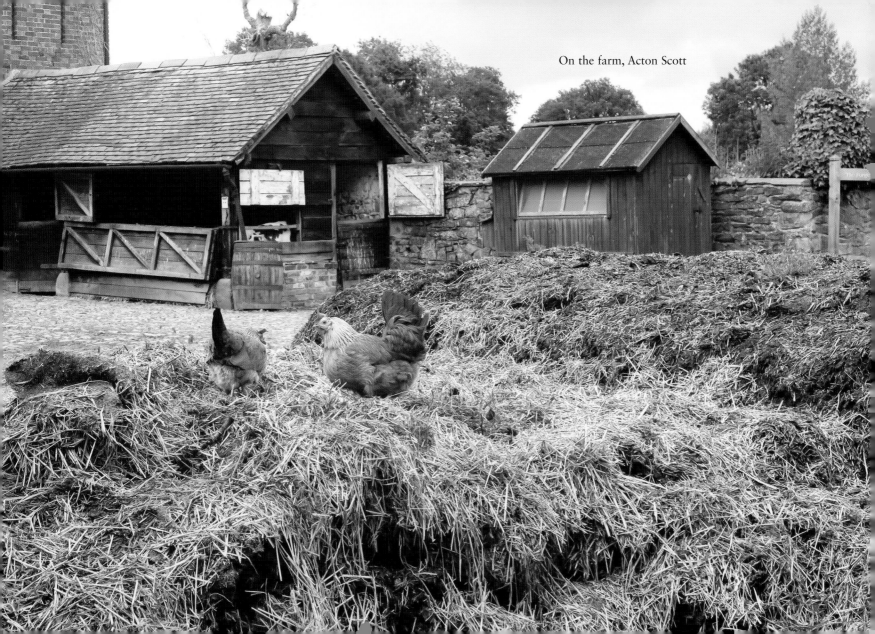

On the farm, Acton Scott

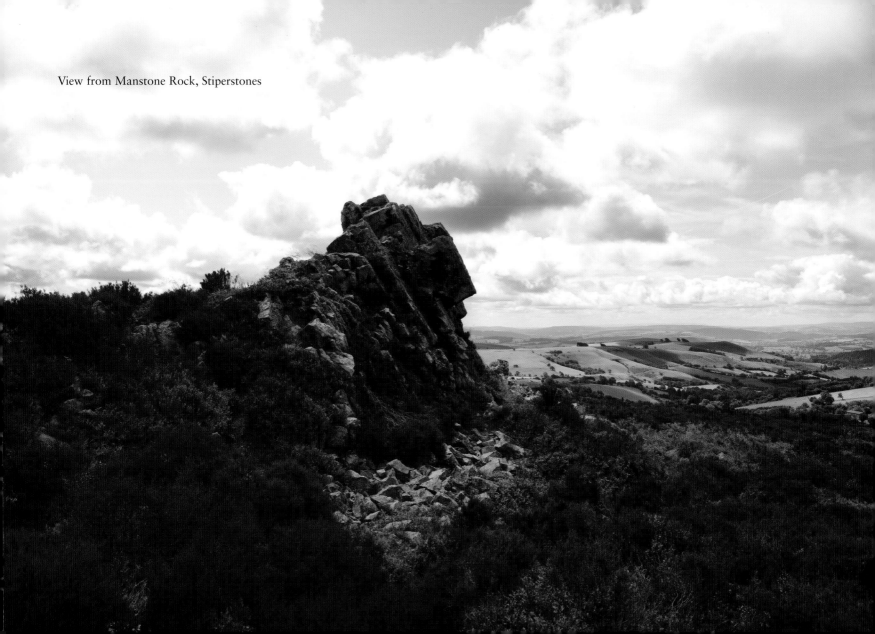

View from Manstone Rock, Stiperstones

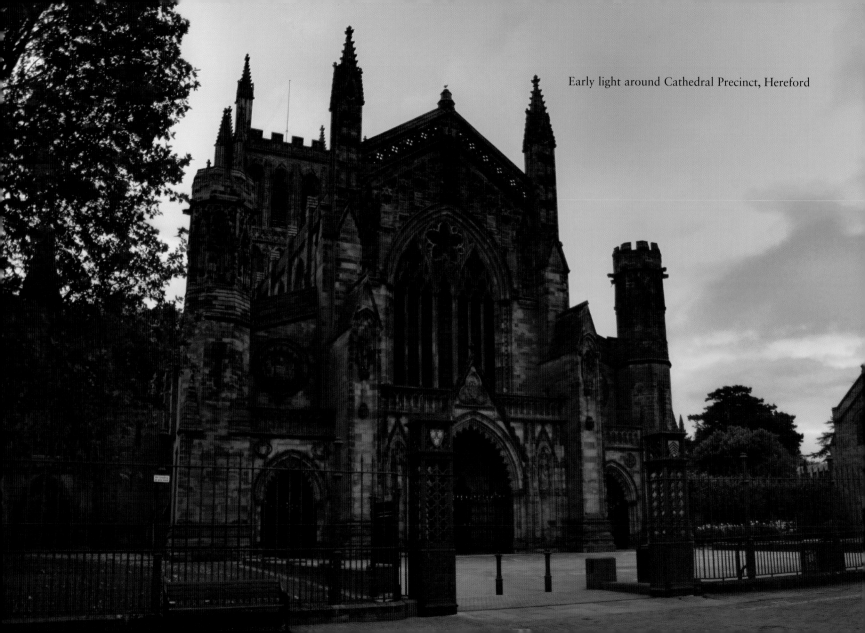

Early light around Cathedral Precinct, Hereford

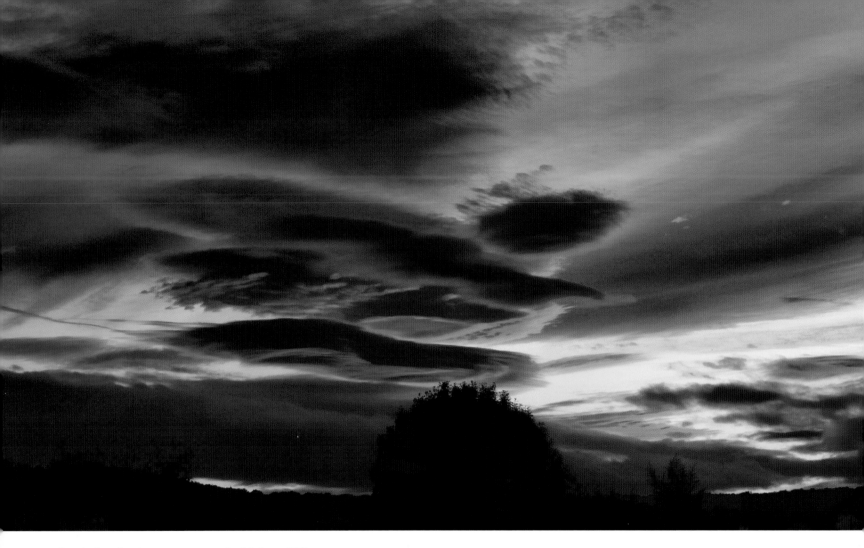

Lenticular clouds at sunset over the Malvern Hills

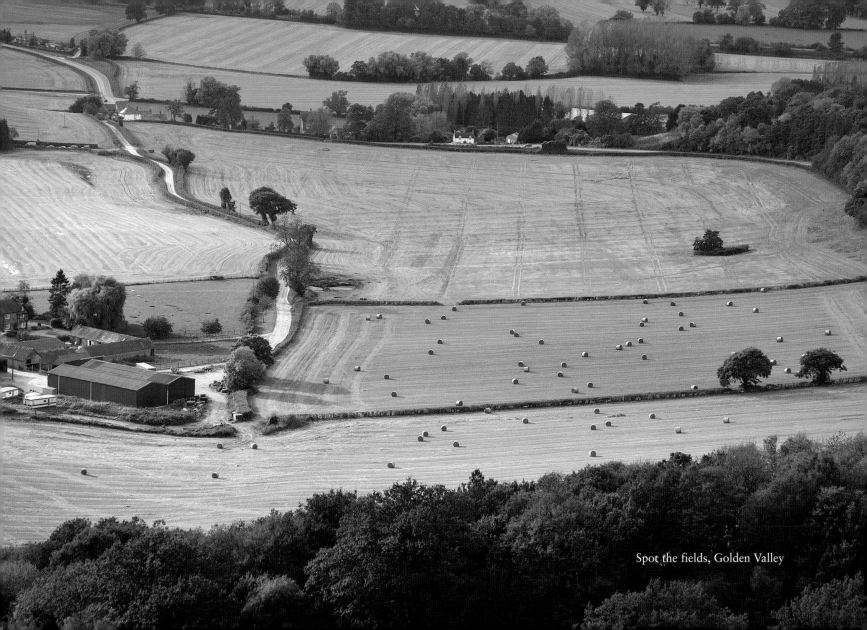

Spot the fields, Golden Valley

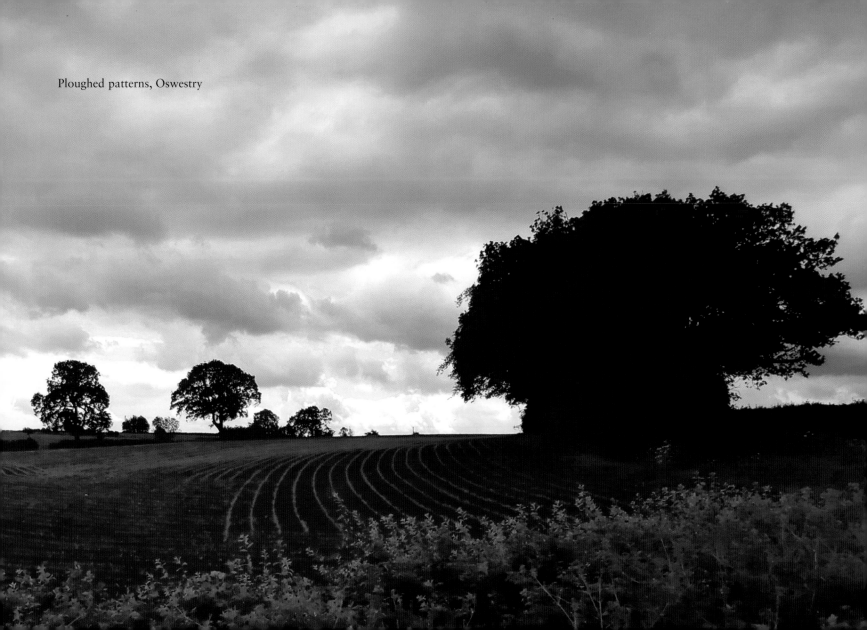

Ploughed patterns, Oswestry

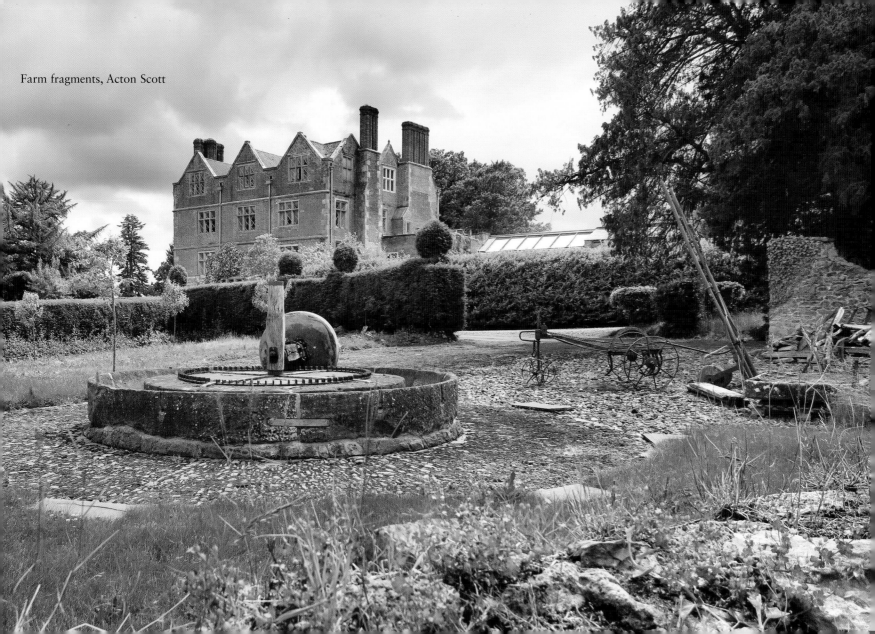

Farm fragments, Acton Scott

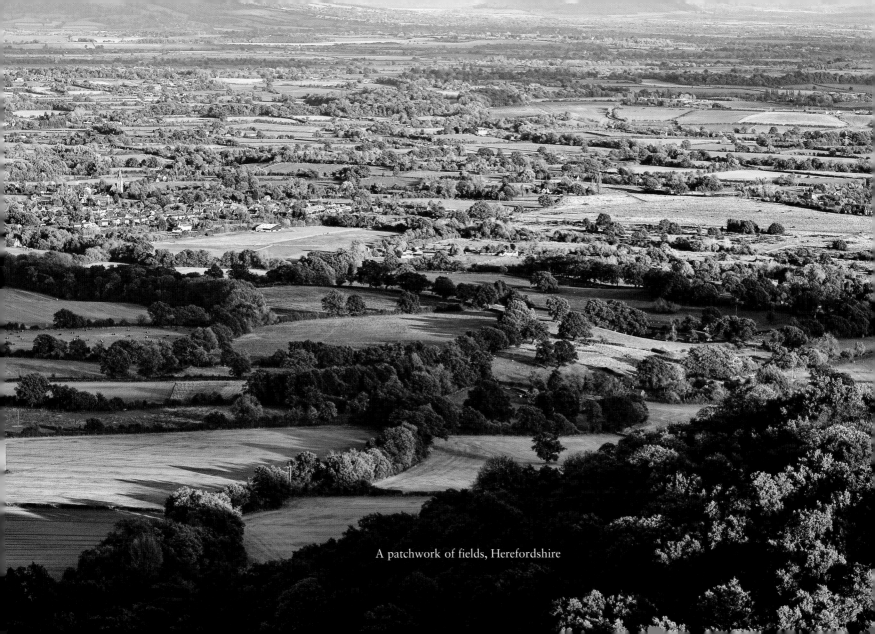

A patchwork of fields, Herefordshire

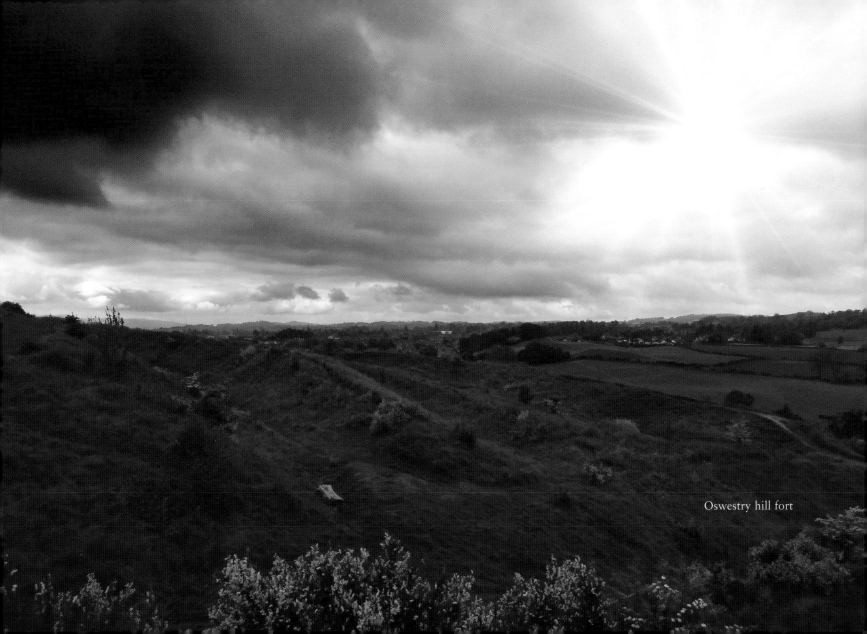

Oswestry hill fort

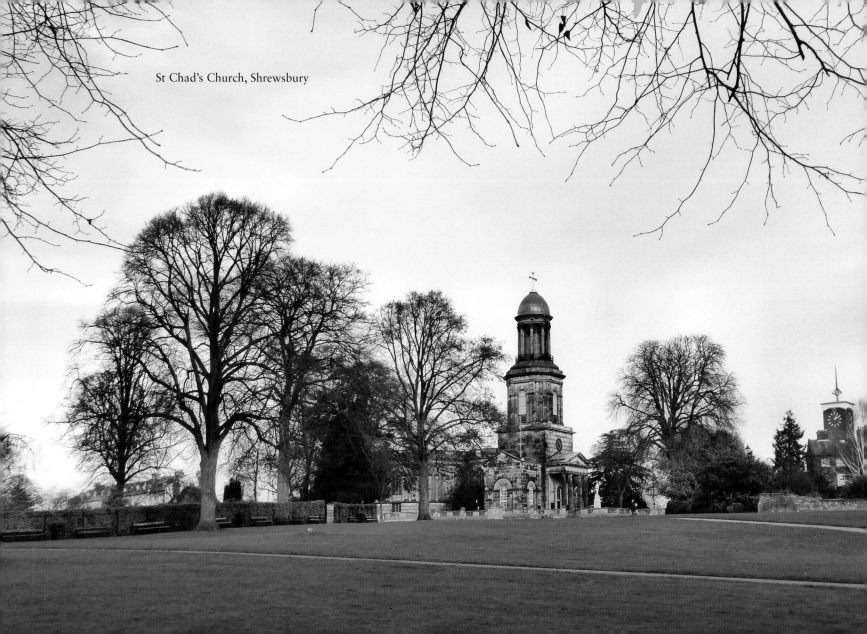

St Chad's Church, Shrewsbury

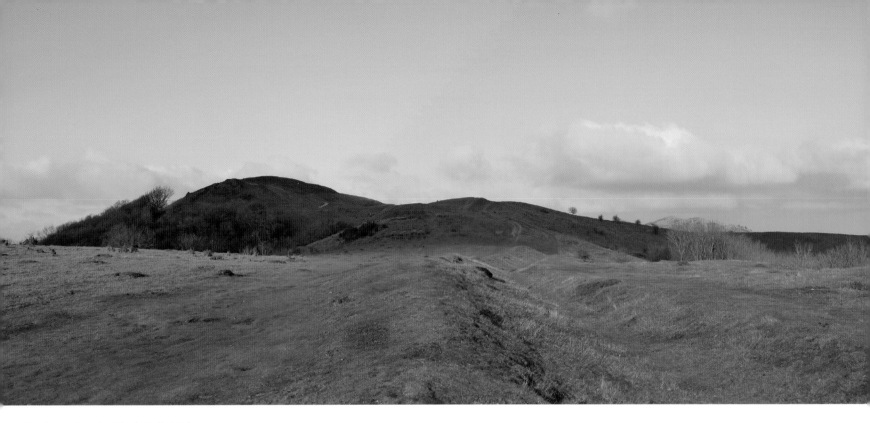

Tracks and trails, Black Hill, Malvern

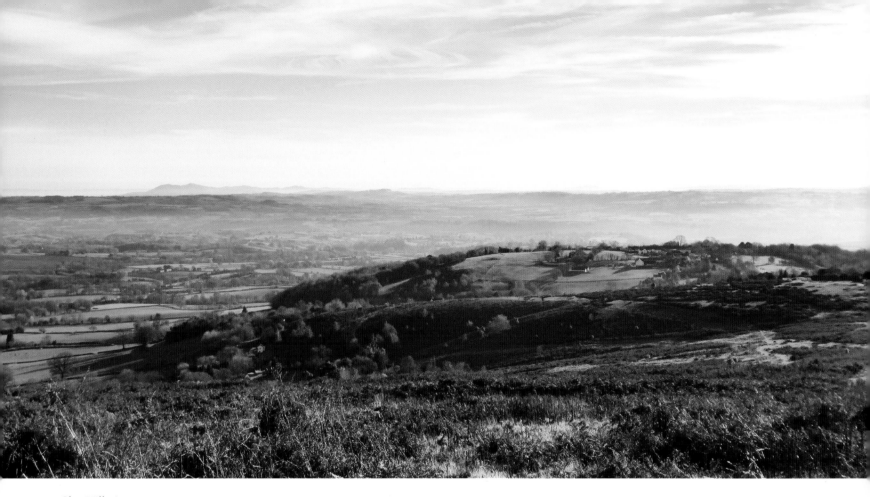

Clee Hill views

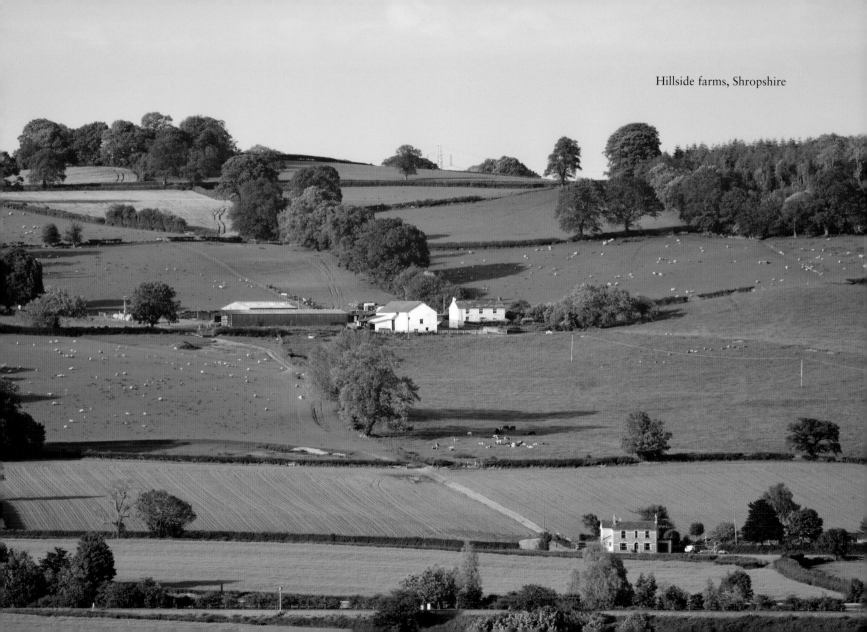

Hillside farms, Shropshire

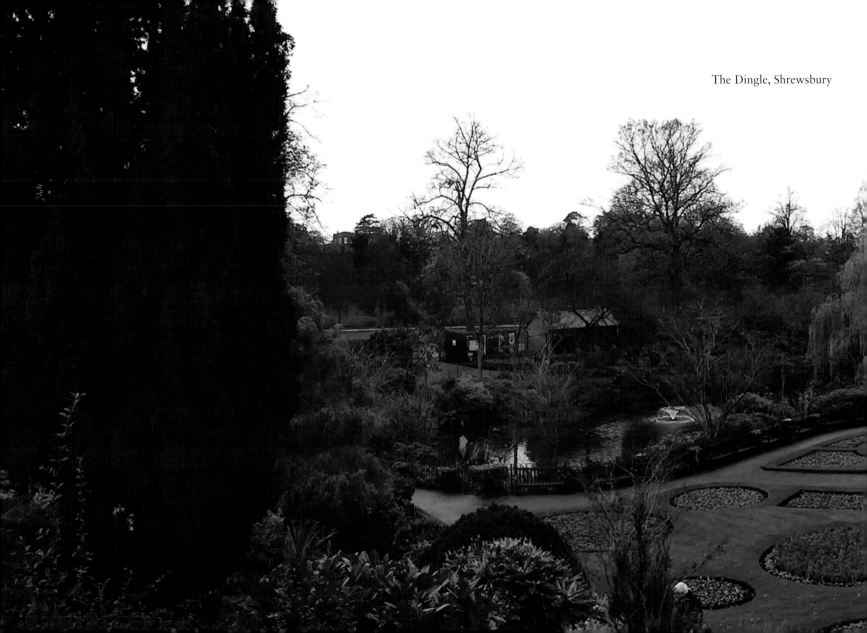

The Dingle, Shrewsbury

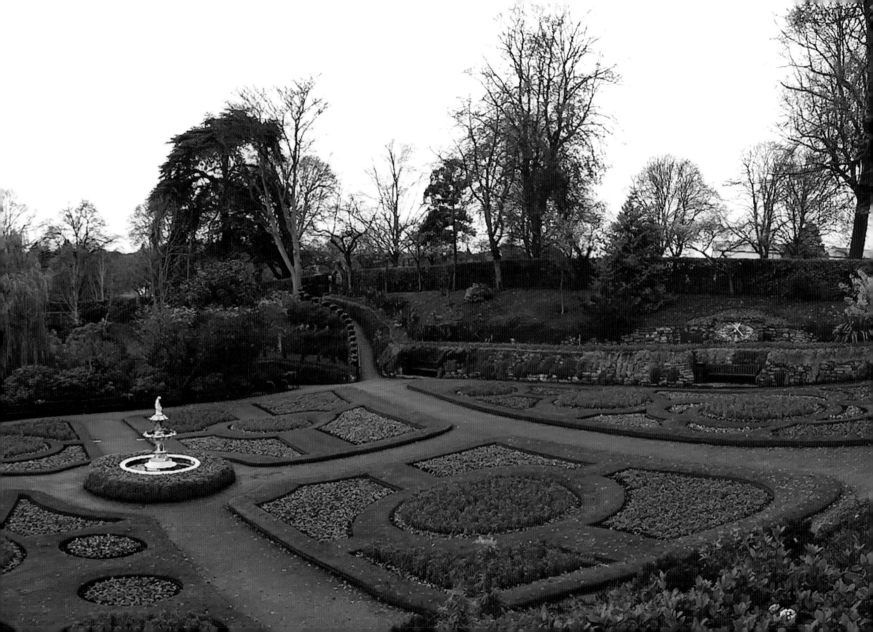

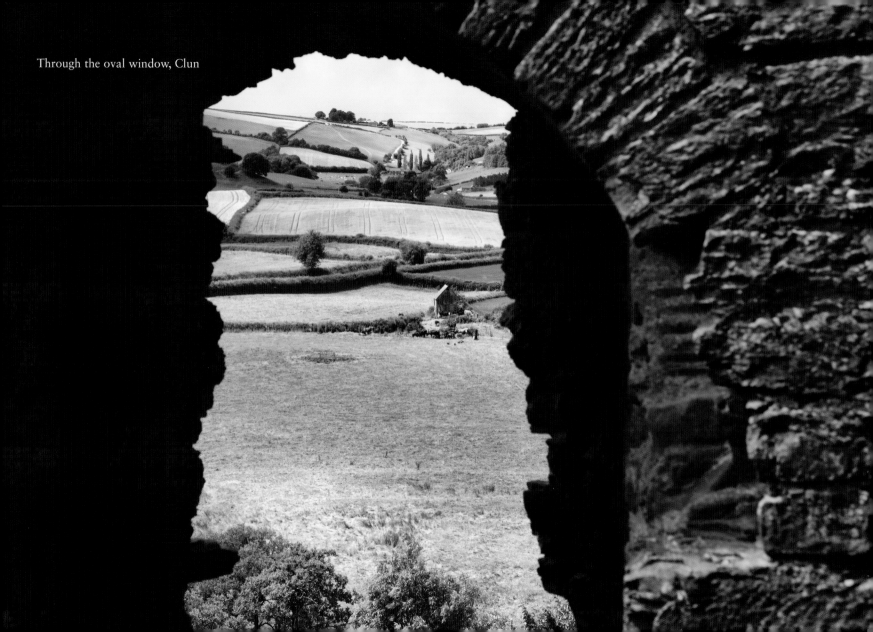

Through the oval window, Clun

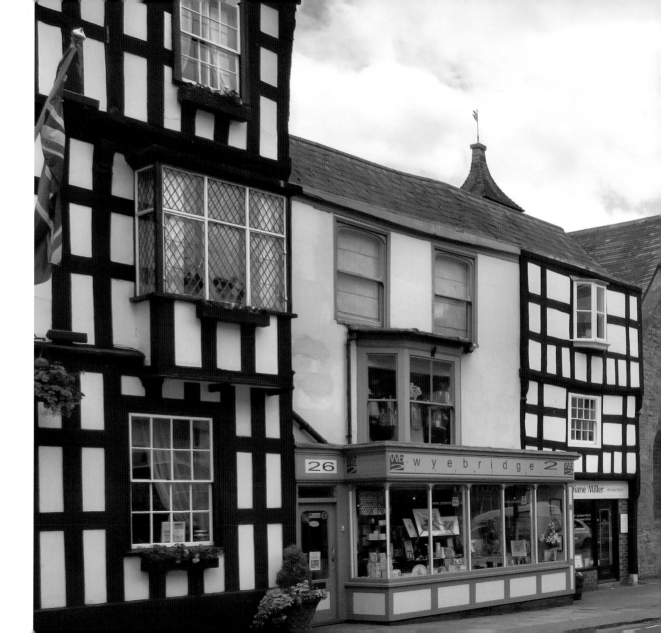

Timbers from history, Ledbury

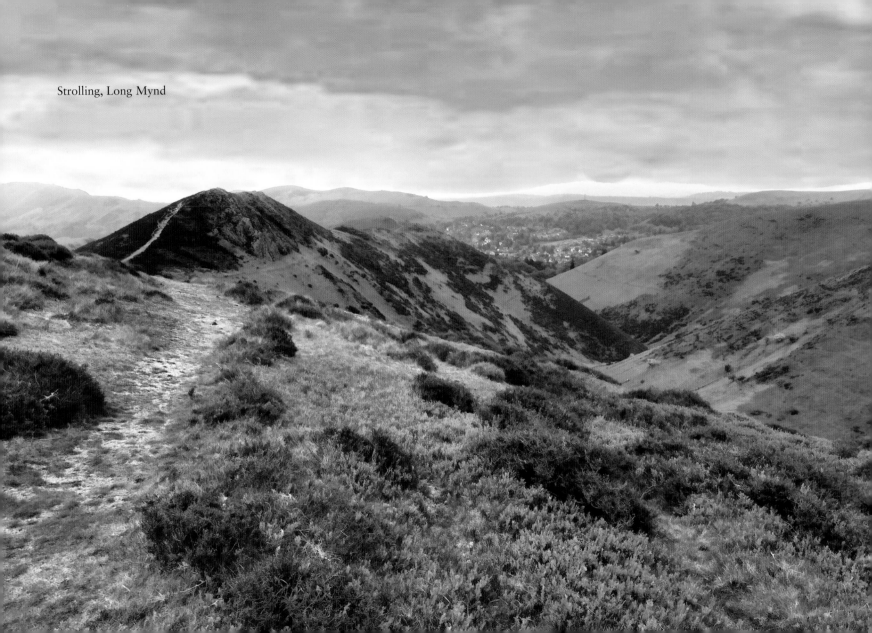

Strolling, Long Mynd

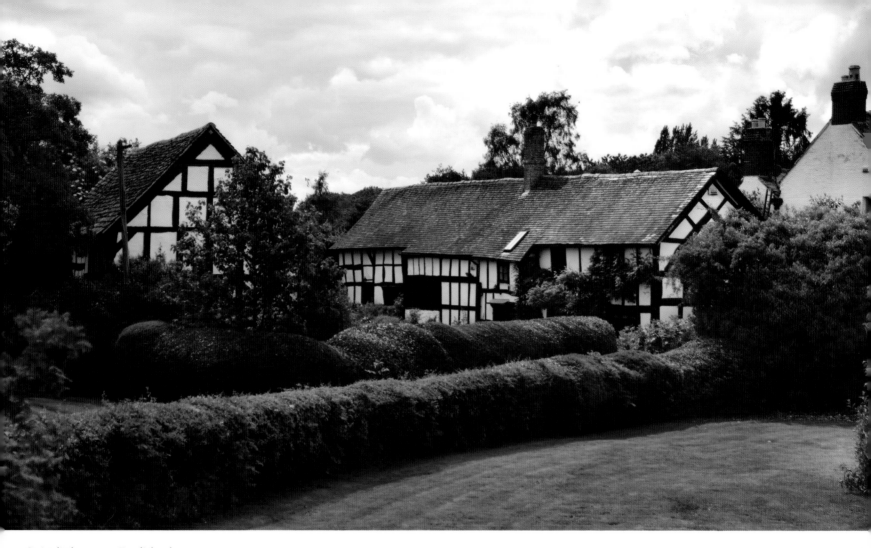

Quiet little corner, Eardisland

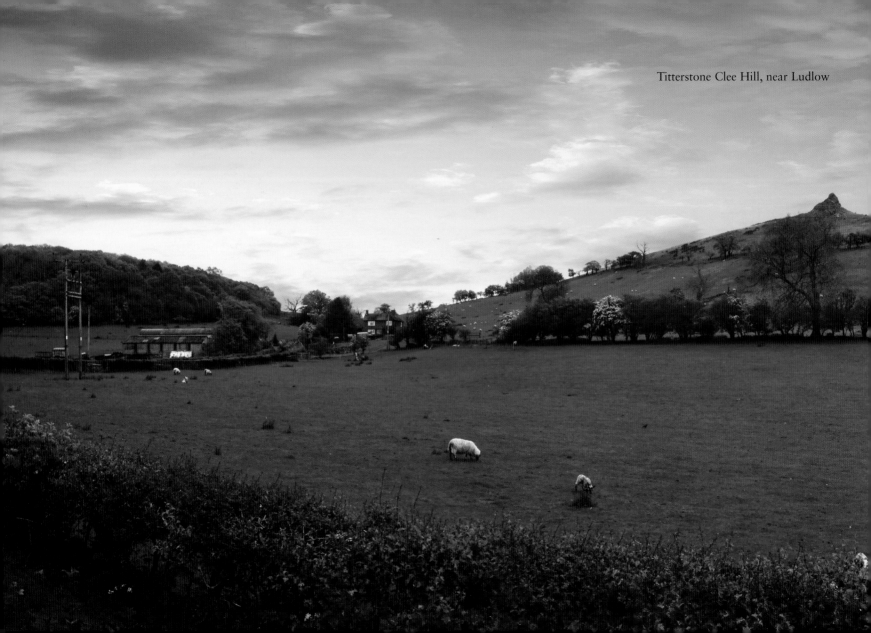

Titterstone Clee Hill, near Ludlow

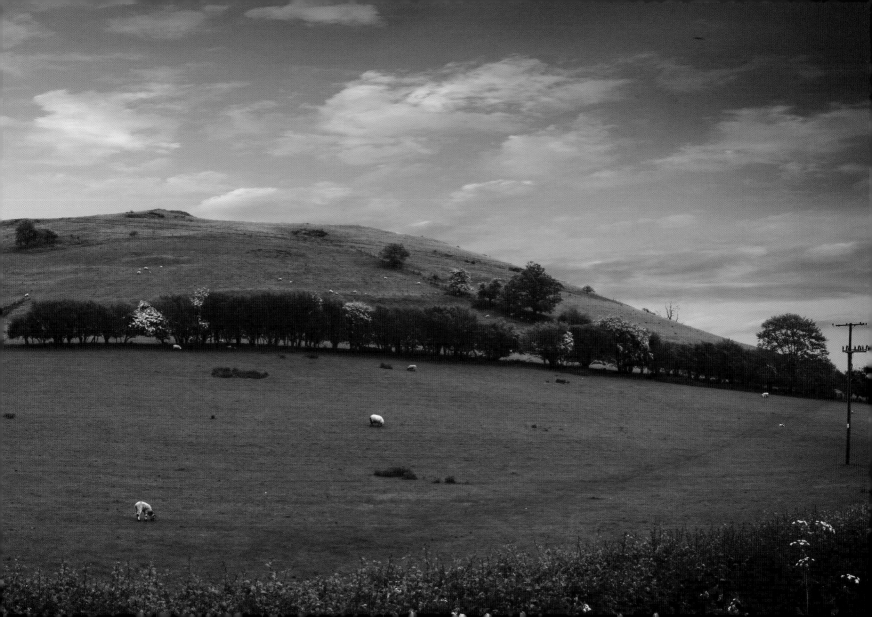

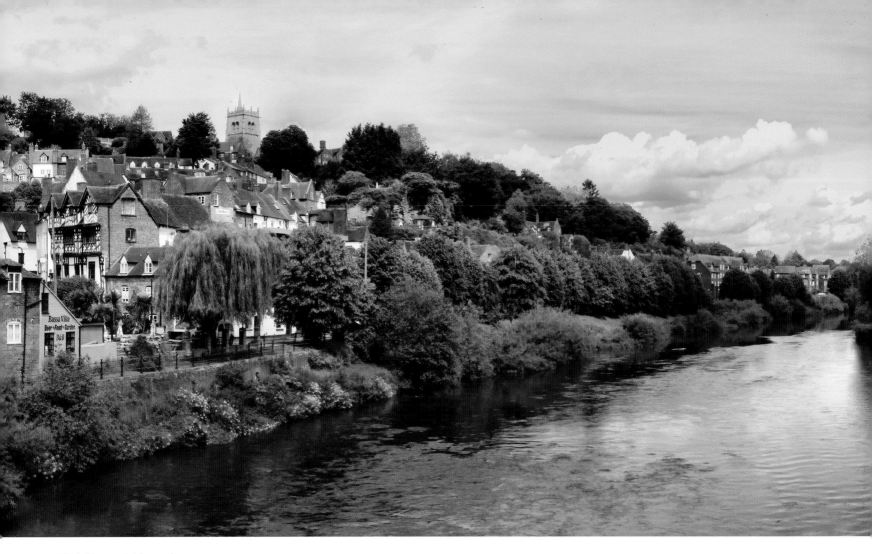

High Town, Bridgnorth

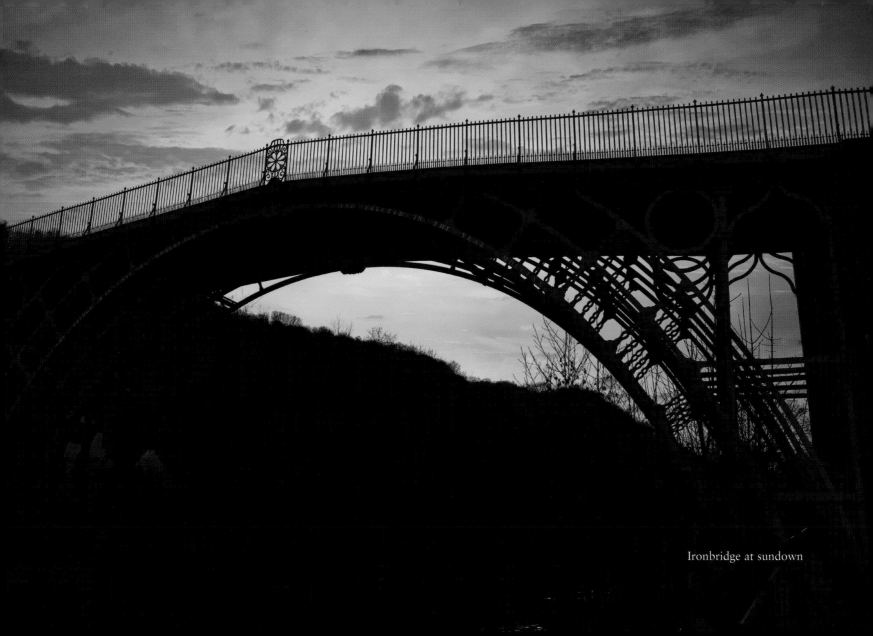

Ironbridge at sundown

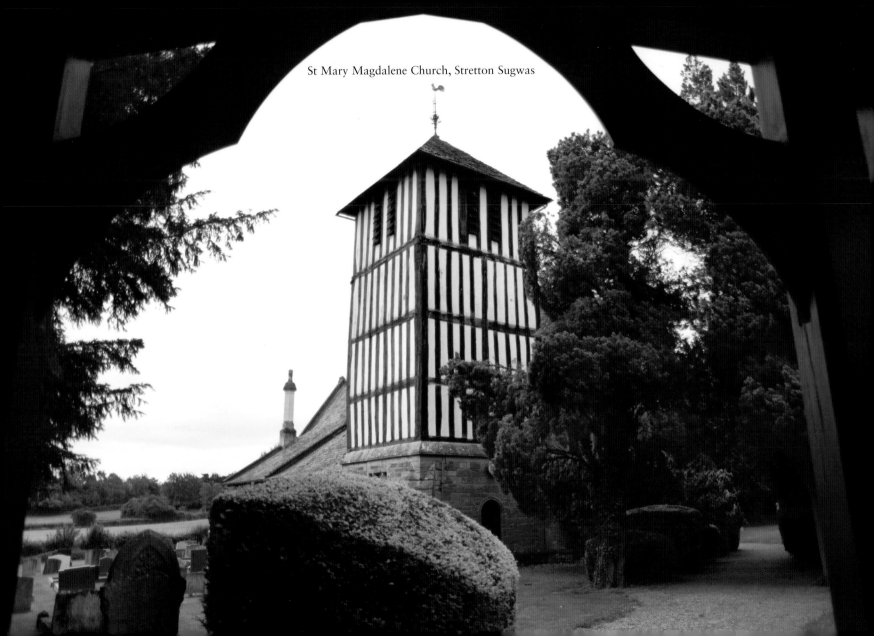

St Mary Magdalene Church, Stretton Sugwas

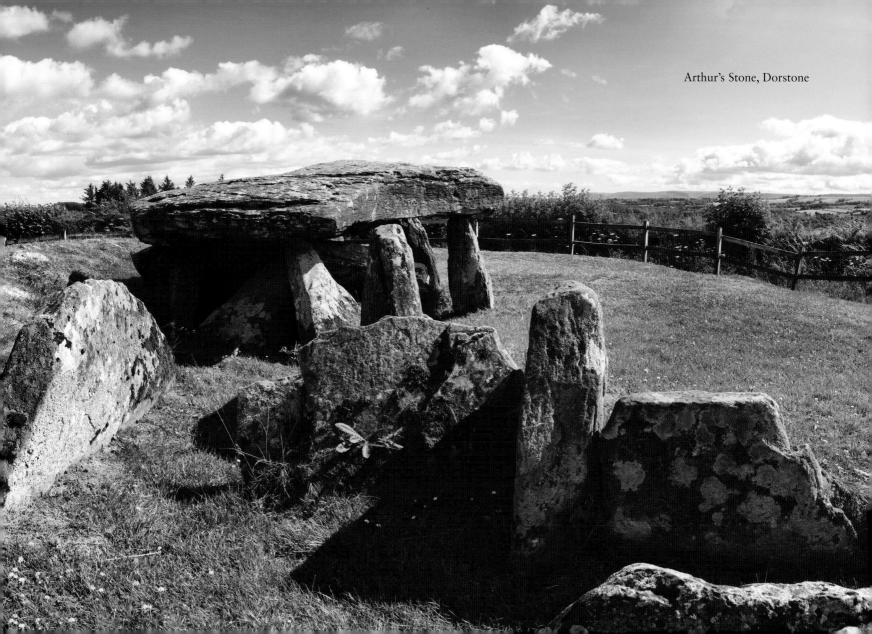

Arthur's Stone, Dorstone

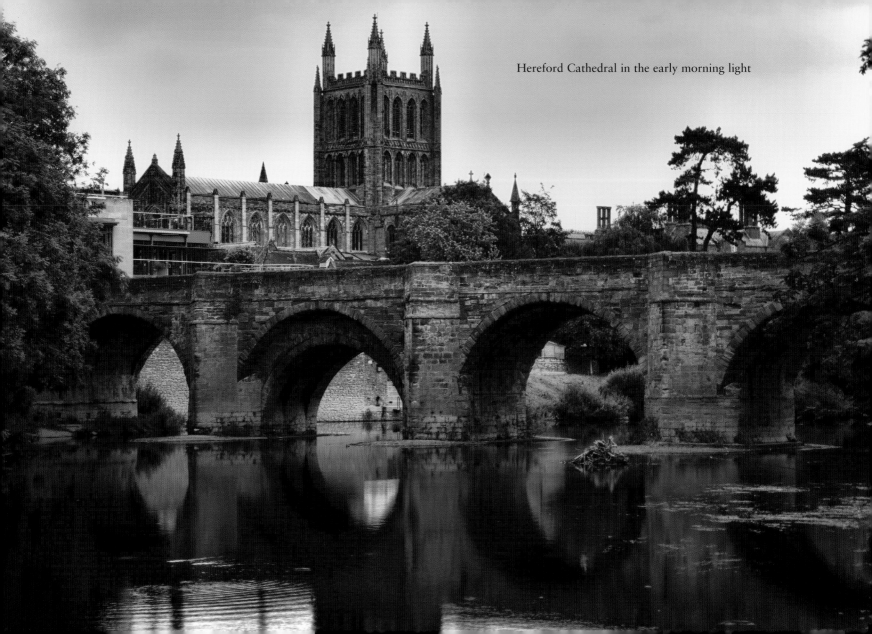

Hereford Cathedral in the early morning light

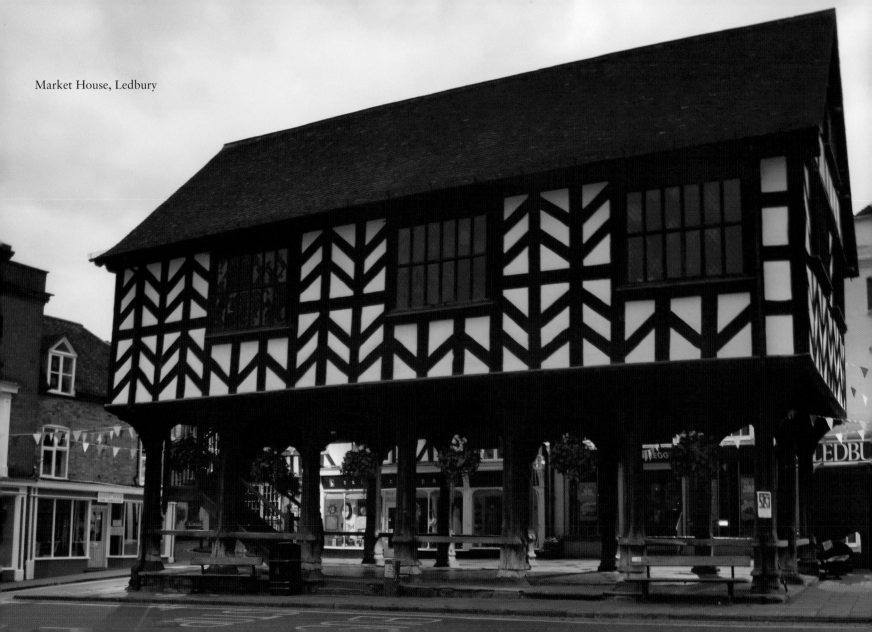

Market House, Ledbury

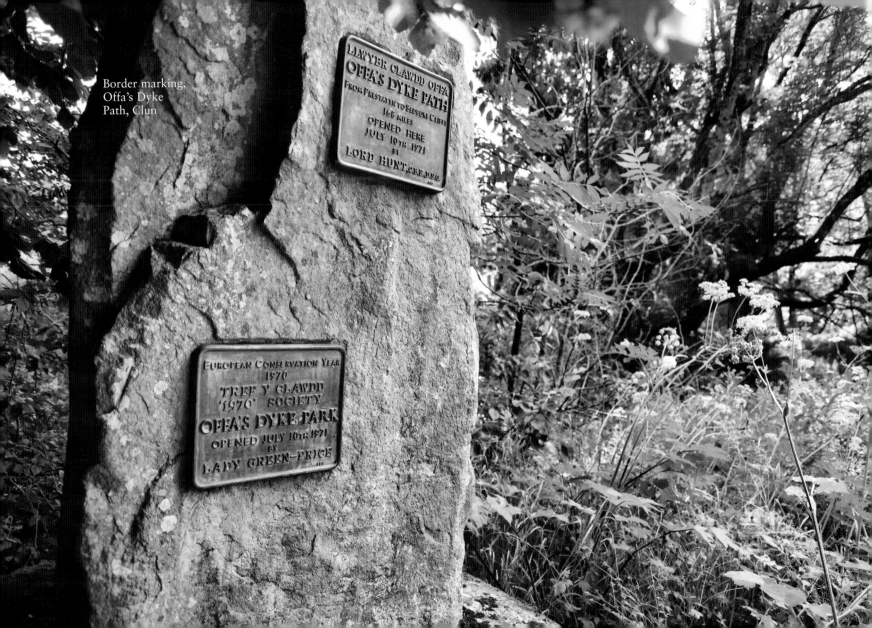

Border marking,
Offa's Dyke
Path, Clun

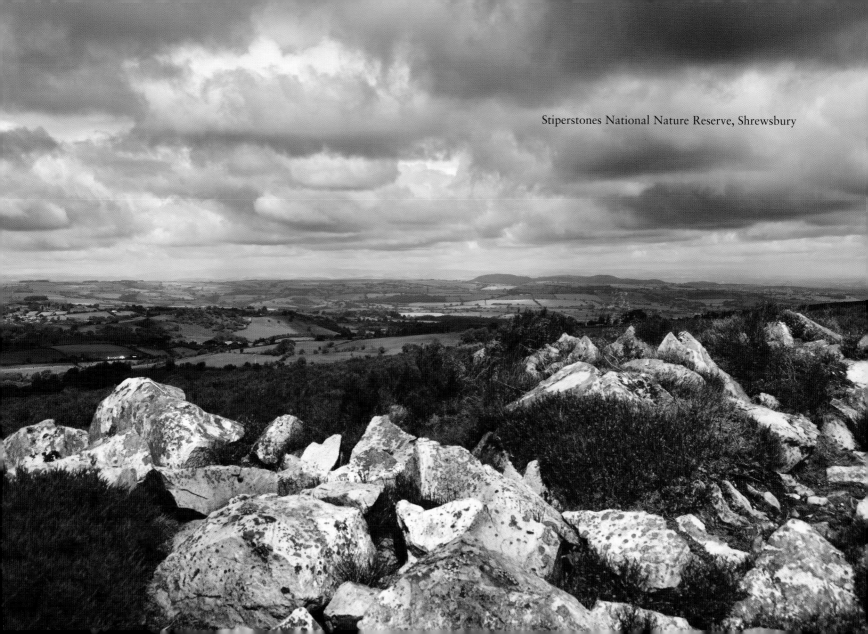

Stiperstones National Nature Reserve, Shrewsbury

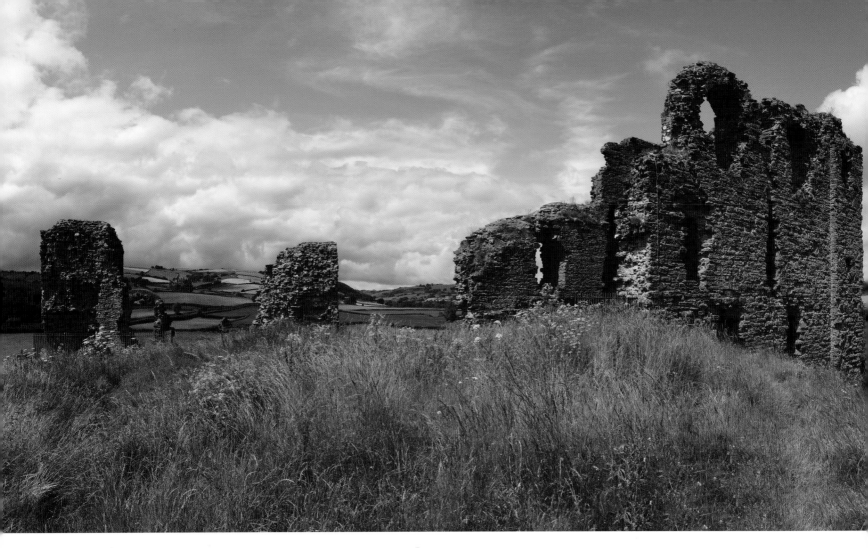

Clun Castle ruins

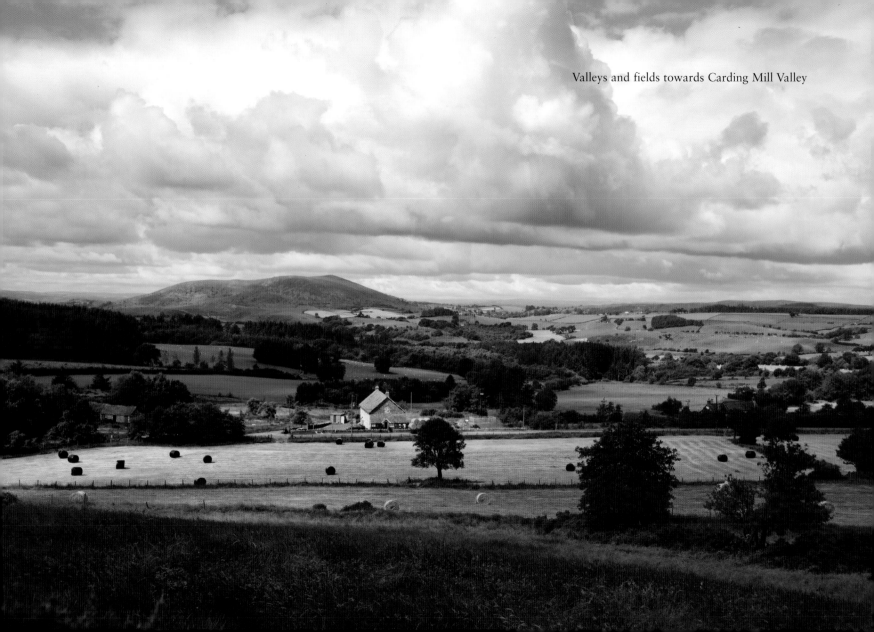

Valleys and fields towards Carding Mill Valley

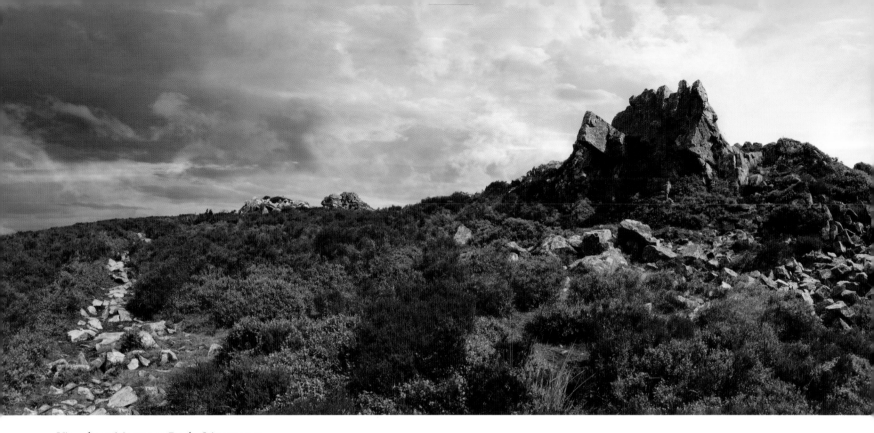

View from Manstone Rock, Stiperstones

SOUTHERN SHORES

Offa's Dyke stretches south towards the Severn Estuary. Along the way, continued evidence of fortifications and boundary lines between Wales and England continue to provide a rich history of the region.

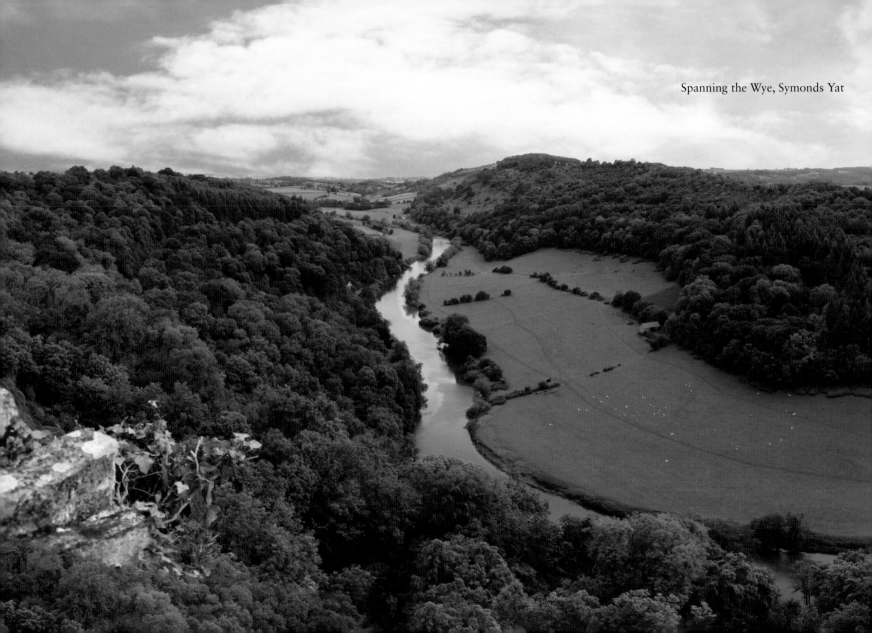

Spanning the Wye, Symonds Yat

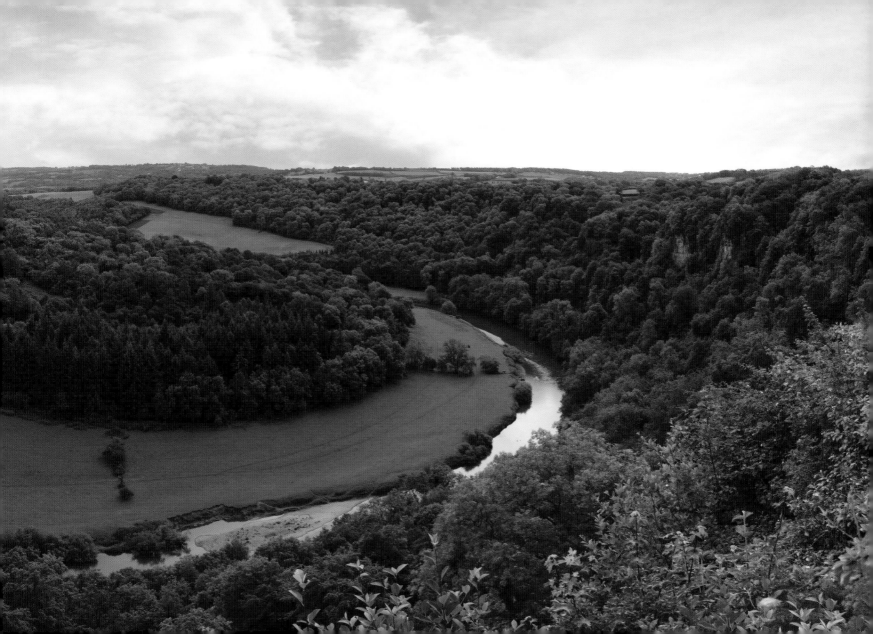

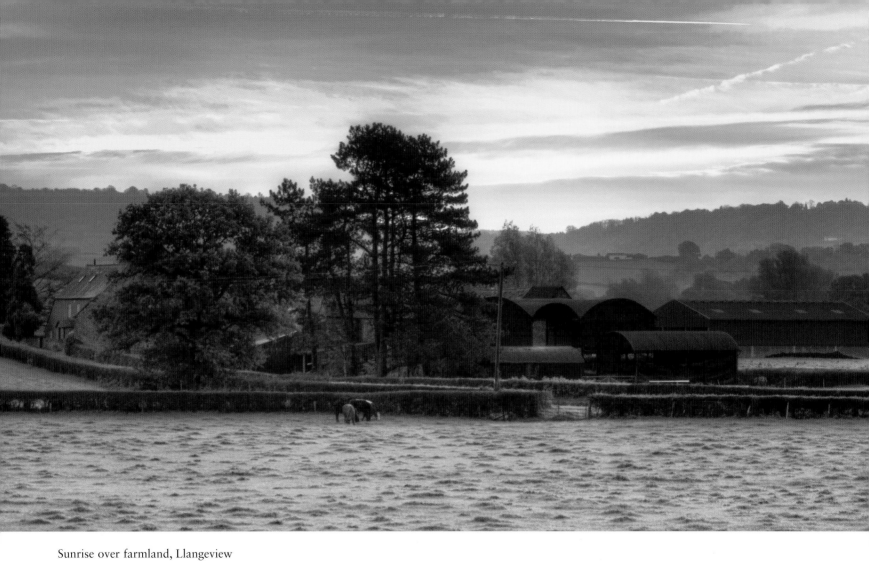

Sunrise over farmland, Llangeview

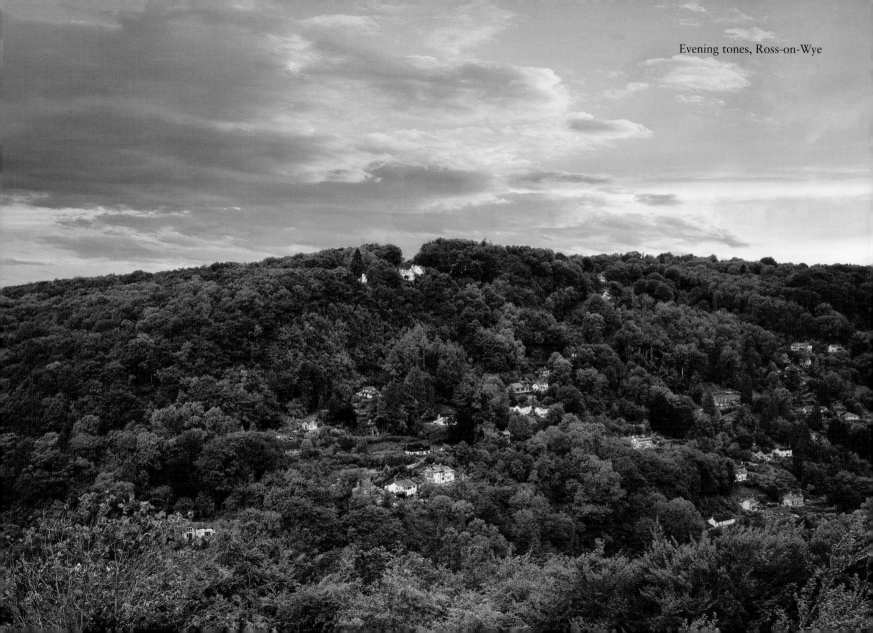

Evening tones, Ross-on-Wye

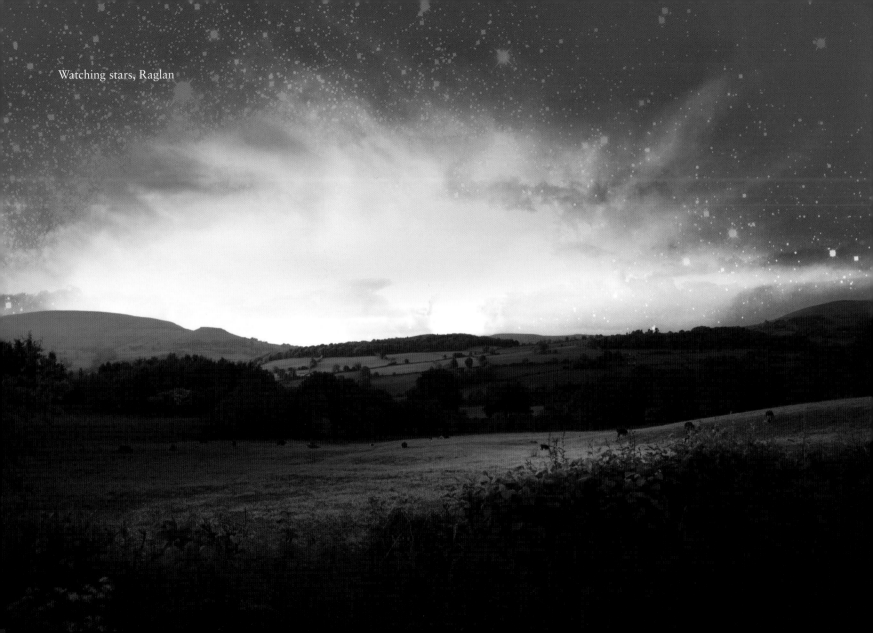

Watching stars, Raglan

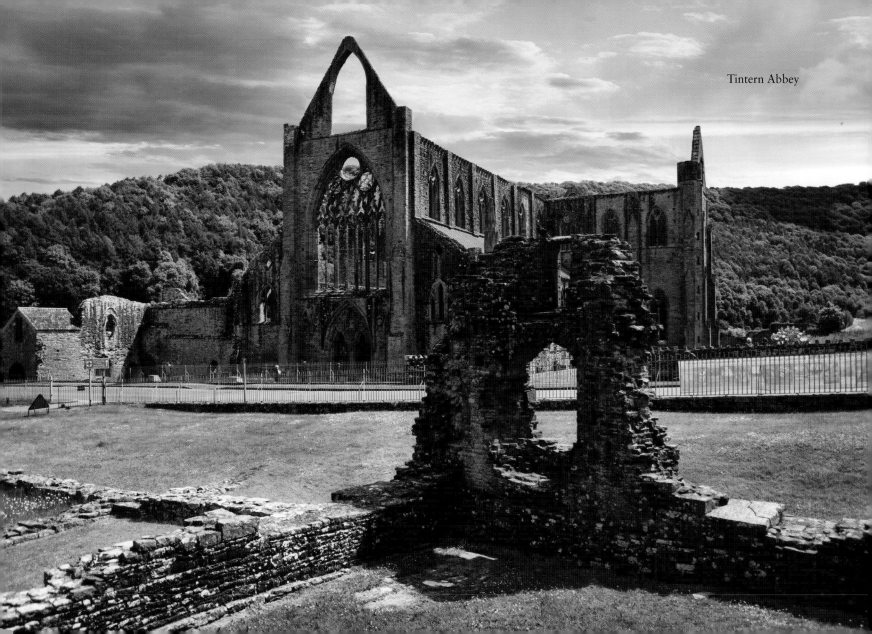

Tintern Abbey

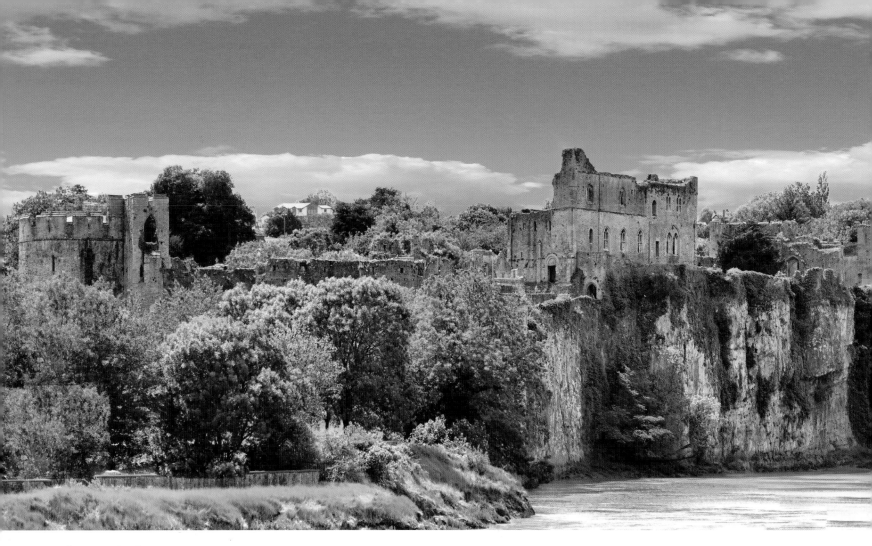

Chepstow Castle

Autumn fields, May Hill, Longhope

Shadows of morning, Monmouth

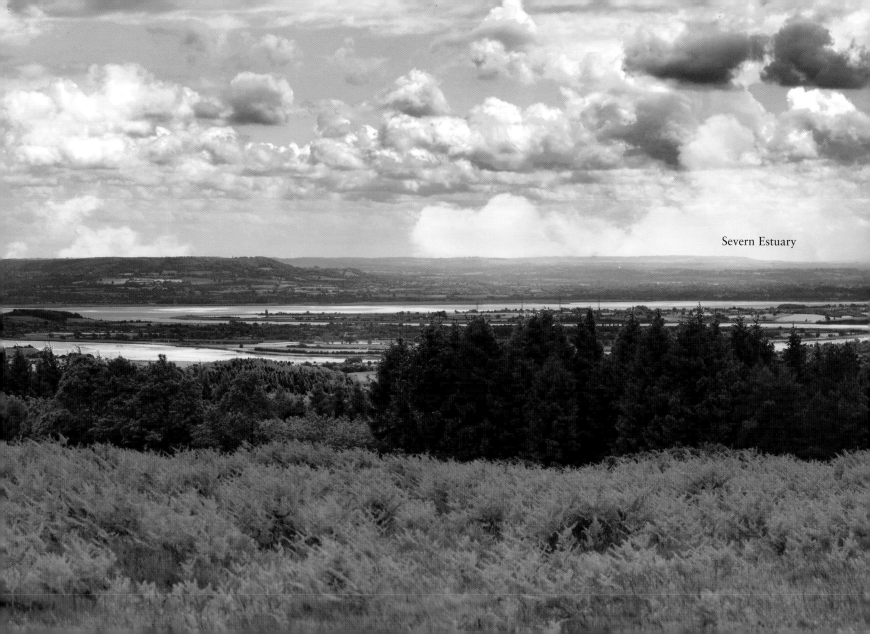

Severn Estuary

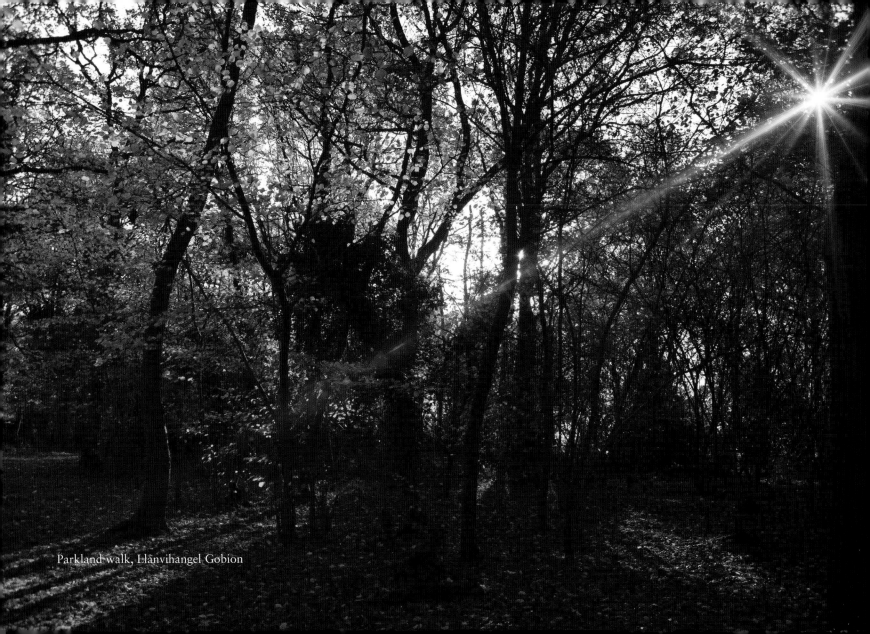

Parkland walk, Llanvihangel Gobion

Nature trail, Bishopswood

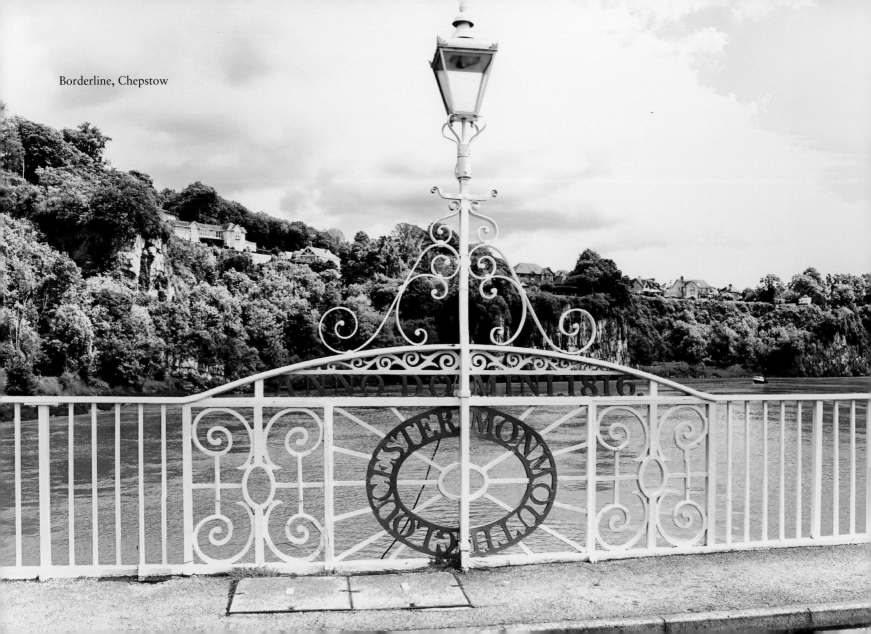

Borderline, Chepstow

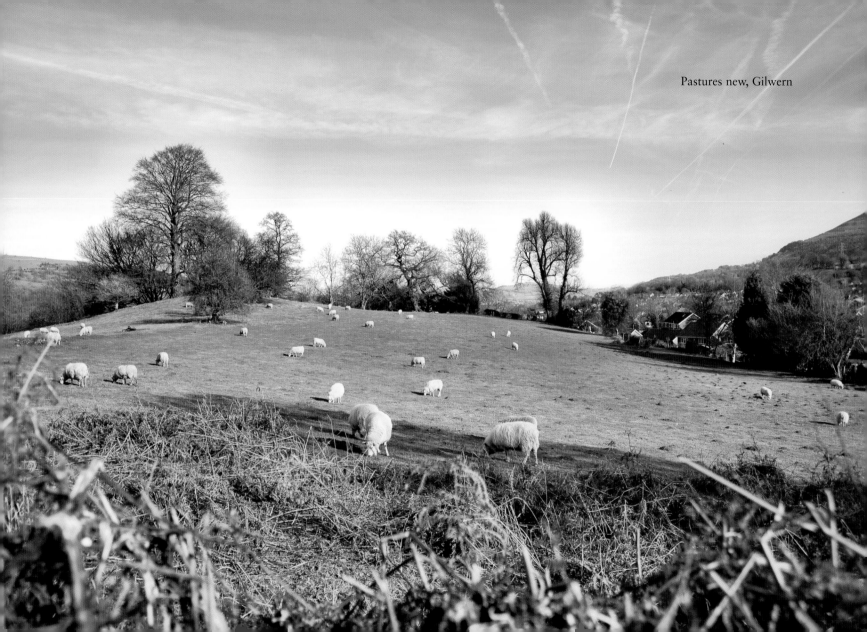

Pastures new, Gilwern

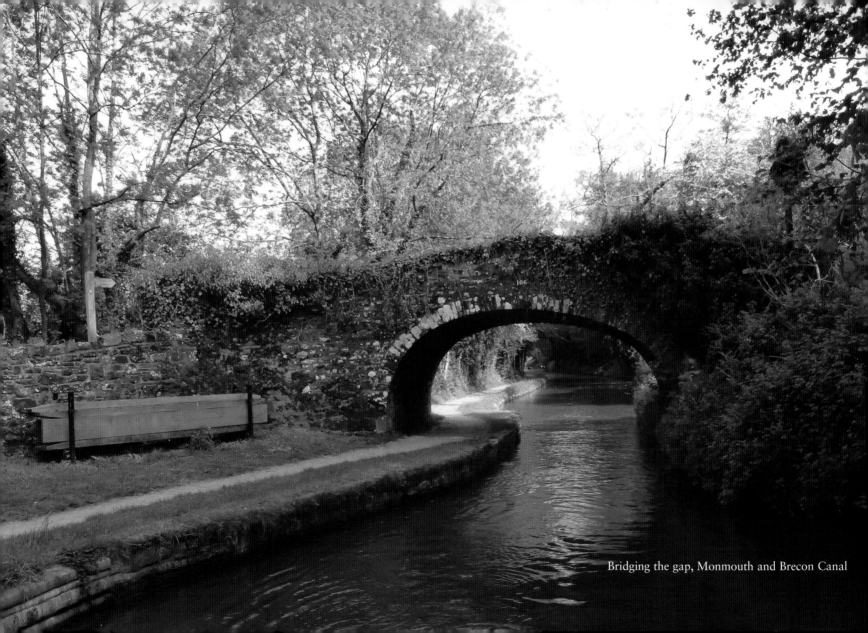

Bridging the gap, Monmouth and Brecon Canal

Moored at sundown, Gilwern

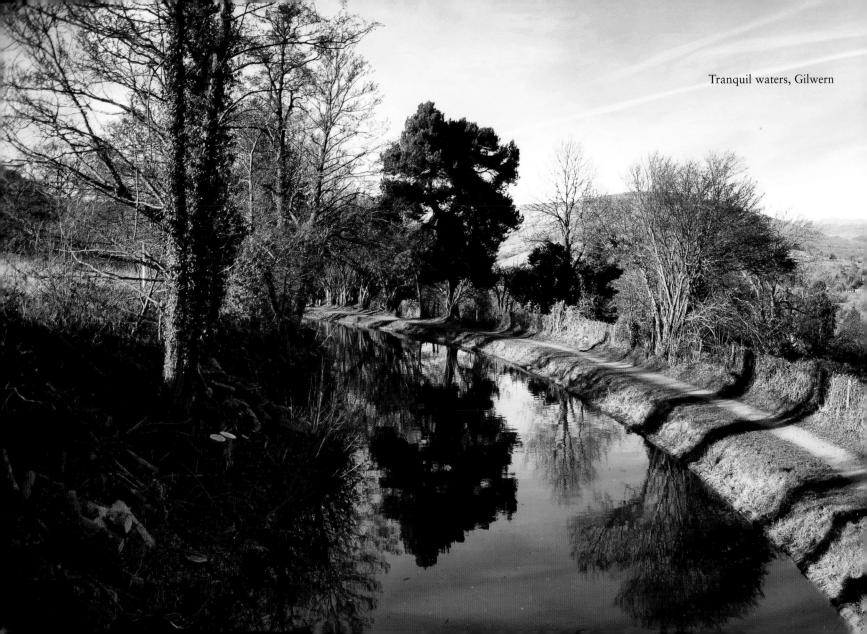

Tranquil waters, Gilwern

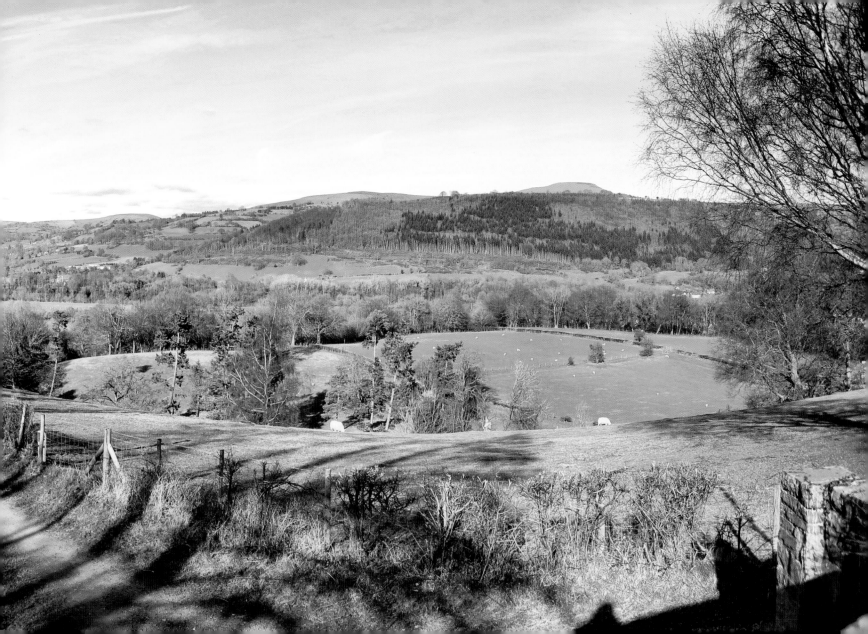

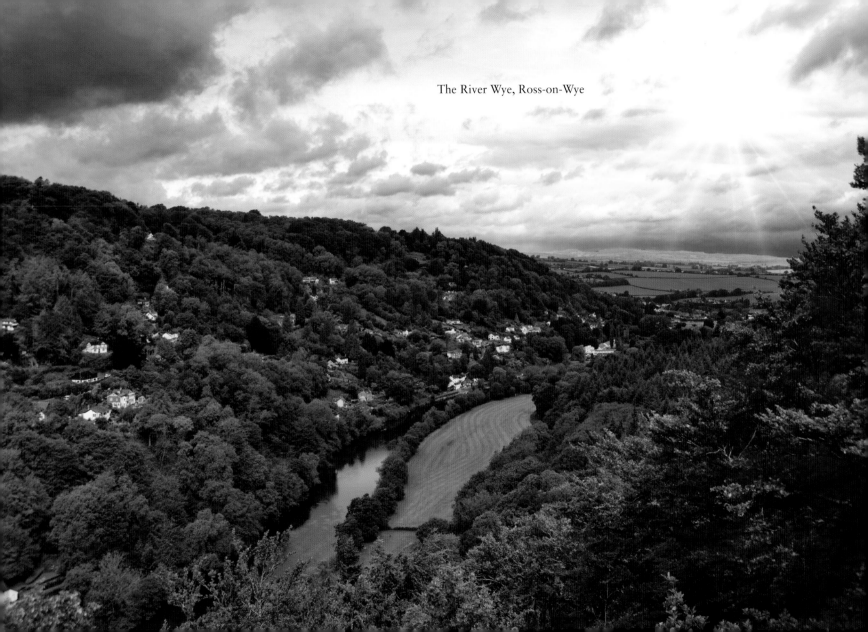

The River Wye, Ross-on-Wye

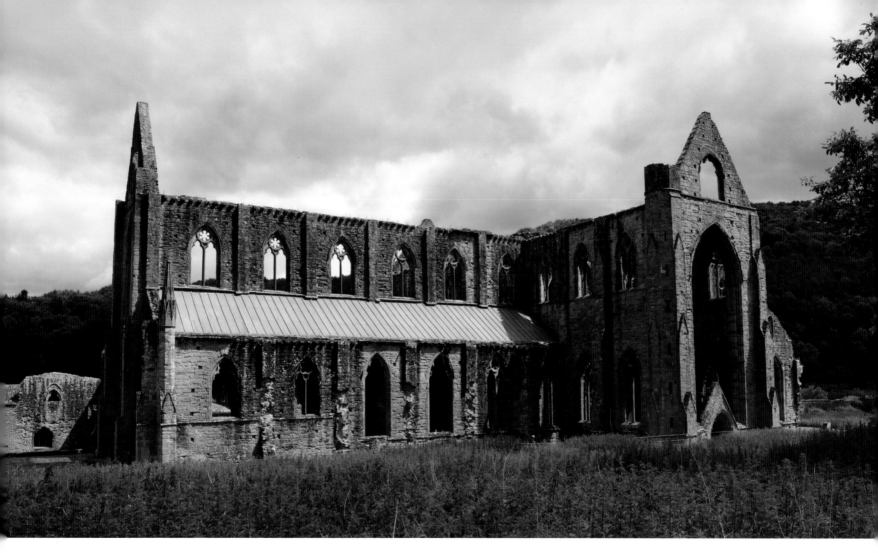

Tintern Abbey

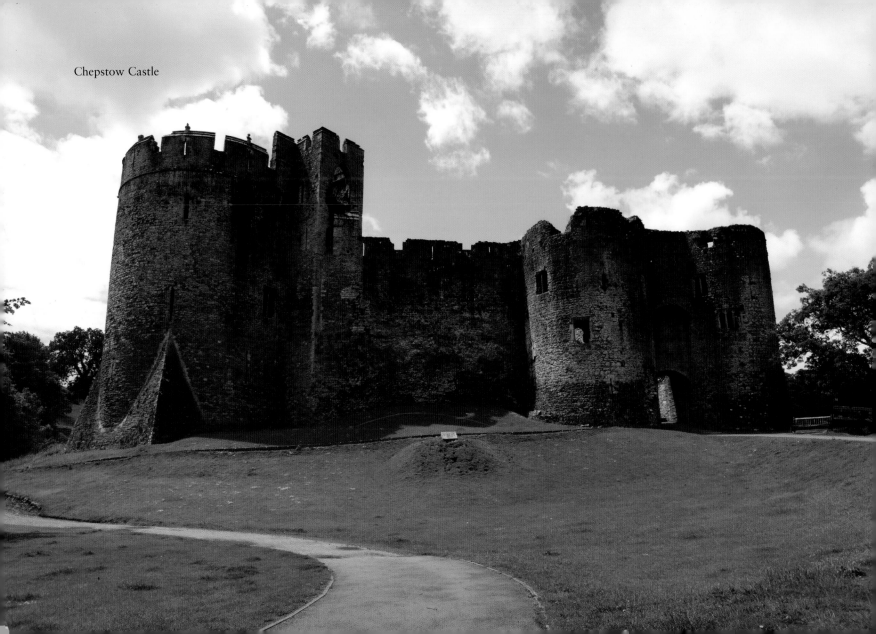

Chepstow Castle

Wooded slopes, Monmouth

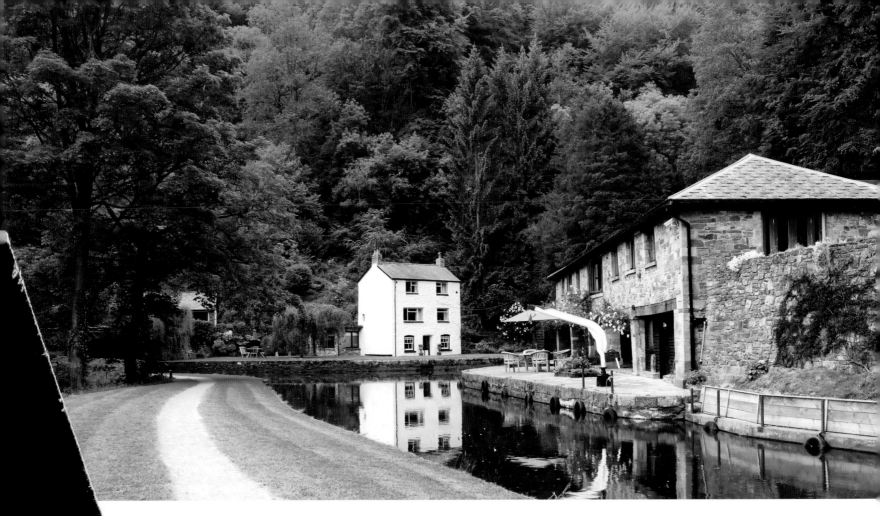

...house, Llanfoist, Abergavenny